Portraits of Resilience

Portraits of Resilience

Daniel Jackson

Foreword by David A. Karp

THE MIT PRESS

CAMBRIDGE, MASSACHUSETTS

LONDON, ENGLAND

This book was set in Minion and Avenir by the MIT Press. Interior design by Daniel Jackson. Cover design by Yasuyo Iguchi. Printed by The Studley Press in Dalton, MA and bound by Acme Binding in Charlestown, MA.

All images © 2017 Daniel Jackson.

Funded in part by the Council for the Arts at MIT. Funded in part by the MindHandHeart Innovation Fund.

Library of Congress Cataloging-in-Publication Data is available.

ISBN: 978-0-262-03678-8

10 9 8 7 6 5 4 3 2 1

To Seth Teller

A brilliant researcher who dreamed of enabling all people

ברוך מעביר אפלֹה ומביא אורה

Blessed be the One who makes darkness pass and brings light
(Sephardic liturgy)

So why would I want anything to do with this illness?
Because I honestly believe that as a result of it I have
felt more things, more deeply; had more experiences,
more intensely; loved more and been more loved;
laughed more often for having cried more often;
appreciated more the springs for all the winters…

Kay Redfield Jamison

Contents

Foreword · xiii

Introduction · 1

Portraits · 7

Acknowledgments · 125

Resources · 129

List of Plates · 131

Foreword

It is often said that we need to put a "human face" on emotional illness, and that is precisely what Daniel Jackson has done in this exceptional volume. It has been a delight for me to learn about Daniel's project and to share our common concern with how emotionally troubled persons interpret and make sense of their lives, subjects I've spent more than two decades myself researching. In *Portraits of Resilience*, Daniel has rendered an invaluable service in providing extraordinarily sensitive and highly instructive interviews to show how some with depression and related problems have emerged from periods of severe mental distress. His own artistry is reflected in striking photographic images of those who were willing to publicly share their courageous stories.

While cultural norms about mental illness are somewhat changing, the reality remains that those suffering from a range of emotional problems are typically silenced, marginalized, and still, today, stigmatized. Far too often they are labeled as "others" who are best rendered invisible and forgotten. In connecting each of the moving accounts in this work with evocative images of the storytellers, Daniel has given both voice and presence to those who experienced challenging illness episodes. In this way, he disrupts the dominant cultural narrative that these folks are simply broken, perhaps irredeemably so. *Portraits of Resilience* thus serves the critical political function of countering hurtful myths about those whose lives have been interrupted by depression and anxiety; once properly understood, they are quite like all of us.

The stories in this volume do far more than simply acquaint readers with the unique struggles of those who speak. Equally, their accounts reveal important and common aspects of the depression experience and, thus, offer insight into how we best conceptualize and understand emotional travails. In this regard, I note how the narratives collected call into question simple, formulaic claims about the causes of extreme sadness or the best approaches for resolving the problem. While appreciative of psychiatry's important knowledge, there is a dangerous myopia in considering emotional illness as primarily the product of a diseased brain, the result of neurotransmitters gone awry. As I read these histories, I am reminded how important it is to recognize the inevitable connections between human pain and the social contexts of our lives.

While readers will no doubt leave this book with a deeper appreciation for the role of biological, psychological, cultural, social, structural, and institutional factors in the suffering described, I want to highlight a few prominent social motifs of the narratives offered. Among the most frequently repeated themes encountered is the absolute centrality of human connections for our well-being. It is a paradox of depression that while sufferers yearn for human connection, their unrelenting despair often robs them of the capacity to realize it. Still, over and again, the accounts in the pages to follow are filled with expressions of gratitude for friends, family, and communities who empathized with their plight and helped to free them from the self-eroding isolation generated by depression and anxiety.

Beginning with the development of sociology during the industrial revolution of the nineteenth century, writers have maintained that the "social bond" fostered by a vital community life was progressively weakened as society became resolutely committed to an ethic of individualism. A number of classical social theorists greatly worried about this paradigm shift. They were concerned that an emphasis on individual rather than collective needs would be the basis for a range of human difficulties. Indeed, the stories you will shortly encounter provide support for the idea that what we call mental illness may very well be a normal response to problematic social structures.

If I am to emphasize the social correlates of emotional problems, we cannot disregard the fact that the interviews to follow were conducted within a single institution: MIT. The respondents in this study repeatedly spoke about the persistent stress imposed by an academic world that demands hyper-achievement. Those who primarily measure themselves in terms of strict academic standards are susceptible to losing sight of their personal needs, attentive as they are to the expectations of others. Thus, for many, the key to greater wellness was contingent on discovering what they truly value in themselves and then pursuing personally relevant goals. In addition, there are those interviewees who attributed their depression to

such stressful experiences as severe physical illness, personal trauma, or family dysfunction. Of course, beyond the boundaries of MIT, we should not be surprised by the exceedingly high rate of depression in the United States given such persistent stressors as poverty, occupational instability, and racial inequality.

Questions about self-fulfillment are abundantly reflected in respondents' comments about the importance of spirituality in their lives. Although I am suspect of claims that persons need only change their attitudes to escape states of emotional turmoil, I am struck by the several stories involving moments of life-altering insights. Consistent with my earlier observations about community, such personal revelations often arose from honest conversations with caring friends, meaningful encounters within university health services, a range of communal activities at MIT, formal religious engagements, or participation in insight seminars.

For many, such broadly spiritual involvements moved persons away from the medical language of cure and toward the goal of personal transformation. The result was a clear amelioration of their symptoms and even tentative claims of recovery. In addition, you will learn that many even talked about the positive dimensions of their struggle—how they "valued" their suffering as a medium for becoming more self-aware, more sensitive toward others, and better equipped to plan a future dedicated to emotional health.

The famous psychologist Erik Erikson once commented that the essence of being human is "hope." Attitudes and practices of resiliency are necessarily rooted in hope. This book engenders hope by focusing on the possibility of defeating profound emotional difficulties. This must surely be a welcome message for those caught in the void of depression; those, in short, who are feeling hopeless and bereft of their very humanity.

I imagine yet another audience for this book. I am thinking of all the individuals who have yet to clearly name their pain. They might recognize that they are muddling through their lives but are either confused about the severity of their circumstance or are unwilling to join the ranks of the "mentally ill." Perhaps seeing themselves in these accounts will be a motivating force for acknowledging the need to freely open their hearts to others, to acquire new tools for responding to their malaise, and thereby to place themselves on a more effective path for bettering their lives.

Let me end by returning to a caveat earlier mentioned. Although I applaud those interviewed for their steadfastness in responding to personal adversity, we must be careful to remember that depression and related emotional troubles come in a startling array of hues, varieties, and intensities. Those who speak in this work reveal important commonalities in the illness experience. Their stories are equally valuable, however, for showing that there is no single, correct approach to diminishing emotional injury. Both therapeutic experts and those close to individuals experiencing exhausting mental pain must first and foremost carefully absorb their stories. Only then can they begin to truly understand the predicament of another's mental anguish and better contribute to their healing. For me, this is among the most important messages of this engaging, informative, and liberating effort.

DAVID A. KARP *is Professor Emeritus of Sociology, Boston College, and author of* Speaking of Sadness: Depression, Disconnection, and the Meanings of Illness *and other books on depression and mental illness.*

Introduction

Depression may seem to be an unpromising topic for an uplifting book. But when I set out on this journey, I had an inkling that members of my community—the students, faculty, and administrators of MIT—would have more to share than sad stories. Perhaps, having entered that dark place, they would emerge with wisdom and clarity—not just about depression but about adversity itself.

I was encountering depression all around. Every term, ten or more students in my class were seeking advice as they found themselves falling behind—and not due to any lack of talent or commitment. Depression took the life of a much loved colleague of mine in the prime of his research and teaching career. And my own family was upended for more than a year by a seemingly intractable bout of depression and anxiety.

As my university community struggled to come to terms with a string of suicides and a survey that found that less than half of our students met the criteria for "flourishing" mental health, it struck me that those who had experienced depression, anxiety, trauma, or similar challenges were not laggards. They were on the front line of our struggle, and their insights and experiences might help us all. So I decided I would try to assemble a gallery of photographic portraits of those strong souls, accompanied by their stories, in the hope that this would bring strength and reassurance to those who were suffering, and a deeper understanding for us all.

I was worried, though. Maybe they wouldn't come. Maybe they'd come, and I wouldn't ask the right questions. Maybe they'd tell me extraordinary things and then decide they were too personal to publish.

I was in for a surprise. Not only did they come, but they shared their stories with an openness and generosity that blew me away. Initially this was a more purely photographic project. I'd hoped to find in the transcript of each of my interviews something pithy and representative to accompany the photograph, but I soon realized there was far too much to distill into a meager remnant. I was being given the gift of an entire life story, and my task was to trim away conversational digressions, and leave the story whole.

I did my best to preserve not only the stories and their truths, but also the exact words in which they were told. My subjects routinely apologized that they spoke in a rambling or inarticulate way, even as I sat mesmerized by their stories. And yet, when I sat down to lightly edit the transcripts of our discussions, I would find revealed in their flowing words ideas and imagery that would please a poet.

This is a subversive project in many ways. People at MIT, like technologists the world over, are often zealous guardians of privacy, and they revel in anonymity. As a lecturer, I long ago gave up asking undergraduates to place name tags on their desks; they'll share their names when asked, but they won't willingly make the first move. It seemed to me that our community's tendency toward anonymity was unwittingly stigmatizing depression even more.

To show that depression was not something to be ashamed of, it would not be enough to break the code of privacy. We would have to celebrate these storytellers, to shine their names in lights, to print not only their stories but also their portraits, to say "Here I am. This is me." For every week of the spring term of 2016, one of these stories appeared in *The Tech*, MIT's newspaper. To my delight, as I unfolded each edition and flipped through to find that week's piece, I would often find that it had been given an entire page, in place of two or three more news items.

This book offers no one diagnosis or prescription. Every story is different. Some found their way back from depression through antidepressants, some through talk therapy, some through meditation. Some kept their struggles to themselves and others found strength in the mutual support of a group. And each story offers its own framing of the nature of our personal and collective challenges, and how we might overcome them.

Nevertheless, some commonalities stand out. As I listened to these stories of often unimaginable hardship, I never once detected a note of self-pity. These are strong and resolute people, and almost all of them say they would not choose to have lived without their depression, even as they would never wish such suffering on anyone else. Many of them commented on how often religion is dismissed at MIT as unscientific dogma, with little recognition of how religious and spiritual engagement (in whatever form) can bring

not just solace but also meaning and fulfillment to daily life. And in almost every story, the power of friendship plays a central role. I was reminded repeatedly that helping doesn't mean solving someone's problems. Often it means just being there.

Few of these stories reach an easy resolution in a life untainted by depression. Sadly, it seems, depression is rarely cured. Like the houseguest you're tired of, it refuses to leave or reappears unexpectedly. But in some sense all the stories have a happy ending: a sense of purpose gained, a strength from knowing that adversity can be overcome, a deeper understanding, a life of greater value.

Some of these stories do close with traumas largely overcome, anxieties quietened, and the numbness of depression replaced by a new zest for life. Some end without a definitive conclusion, in the midst of an ongoing struggle. In listening to my subjects tells their stories, I often had the sense that I was witnessing a great project underway, a fight for meaning and purpose in a world full of trivial distractions.

Ernest Shackleton's expedition to the Antarctic never met its original goal. His ship was trapped in ice and crushed before he even landed, and he never reached the South Pole. But his heroic efforts to save his crew have made his story one of the best known of any explorer's, and it is in the adversity he faced that we recognize the extent of his achievement.

In these stories, we can join in the celebration of adversities conquered. But the true heroism of these extraordinary people lies not in the tragedies they survived or in the new lives they forged, but in the qualities of mind and heart that they show us along the way.

Daniel Jackson
May 2017

Portraits

GRACE TAYLOR

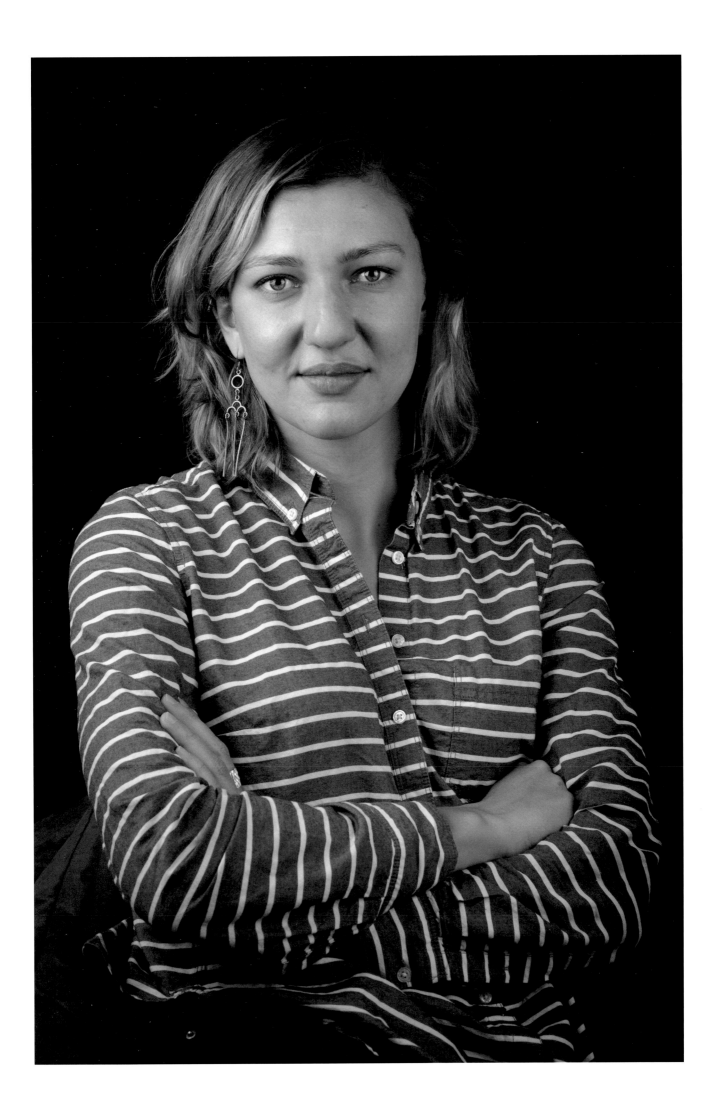

When I was a little kid, I was a little darker than other people. As a child, there's not really a space for that socially. I worried about things more than other people. I was worried about things not going well at home and things not going well at school. I was more existentially fraught than other people. I was concerned about death.

I grew up thinking that was the way that life was, and that life was a generally difficult thing that you had to contend with on a daily basis. I have memories of watching television and seeing ads for antidepressants on TV. There's a little ball that's bouncing, and it's a sad ball with a frowny face, and it's not energetic. Then it takes the medication and becomes happy and engaged. They were telling my story, but not for a second did I consider that that could be what was going on with me.

When I was 11 or 12, I switched schools. I was trying to make new friends, and a combination of stressors brought my depression to a head. It became difficult to get out of bed and go to school. My parents realized something was up, so they took me to a therapist, but I didn't get along with him very well. Two years later, I found a new therapist, and she pretty quickly said, "You should see a psychiatrist, someone who can prescribe you medication." At the time, I thought it was funny. I thought, "OK, I'm really pulling one over on these adults. These people don't know what to do with me so much that they're going to give me medicine." I had no concept that it would actually work.

I took Prozac for the first time when I was fourteen, and it was a really profound experience. It was the first time I realized that my identity is separate from my depression. I felt like myself for the first time. The darkness and sadness and anxiety that I thought was me was actually changeable.

Coming to MIT was the next big awakening in my life. A lot of people were phenomenal in high school, and just killed it in their classes, and then they came to MIT and got depressed. I had the opposite trajectory. I was happier than I had ever been. I went off Prozac my first year at MIT, and that worked for two years. I thought I was cured.

Then, my junior year at MIT, I became depressed again. I don't really know what triggered it, but I do know that it snuck up on me big time. It's like the frog in the pot, where it gets hotter and hotter, and you don't even know you're being boiled. I have this memory of walking to class one morning when I was just so inside my head, and so not engaged with the world around me. The world outside is sad and cold.

The world inside is sad and cold. It's difficult. That feeling is the hallmark of my depression: things become more difficult globally.

I started seeing a psychiatrist at MIT Medical, whom I loved. I remember him saying, "Maybe this is just your adult depression," and basically the thing we're fighting has changed, and feeling like, "Oh, shit. I thought I had fixed this, and I haven't."

Being depressed has made me a bit more laid back about life. In my generation, my peer group, we have really amazing lives that are extremely rewarding and wonderful. We are very successful. We have career choices ahead of us, and sometimes we get the idea that we can win it. We can fix our life. We can use life hacks, put it all together.

I'm strongly of the belief that that is not possible. Life is continually changing. It's something that you engage with and you do your best, and sometimes difficult things happen, and you try to work on them, but it's never solved. It's not an equation that you solve, and then you just have your happy life and it keeps going.

I have many dear friends who are engineers, and who are depressed, or have difficult things going on in their life. I suggest therapy to them, and they say, "Why is that going to do anything?" They say, "I've talked about that before, and it's hard to talk about, and why would I talk to someone else about it? Explain to me why that's going to do something." And I can't really. I've been in therapy on and off for over ten years, and I don't really know why it works, but it definitely works.

It's easy to want to apply engineering principles to everything in life, but they haven't really helped me with my depression. The principles that helped me with my depression are things like: it's good to be kind to yourself; there is value in being vulnerable with other people; it's good to be kind to other people. And there is inherent benefit in talking about things that are hard, even if you don't understand why.

Anecdotally, the pattern I've seen among my close friends at MIT has been a toughness that prevents them from getting into talk therapy or medication. They're plenty comfortable waxing philosophical about all kinds of things, but sitting down and exposing themselves just isn't something that they're familiar with.

I was in Course 10, Chemical Engineering, and then basically decided that I wanted to be a doctor and switched to Course 7, Biology, because I thought it would be more relevant. I didn't need to stay up until

two in the morning learning about reactors when I was going to be a doctor. I was really embarrassed to admit that to people, that I had switched from an engineering course to biology, because I thought that they would assume that it was because I couldn't cut it in engineering.

Of course that's ridiculous, and biology is a complex and fascinating and difficult subject, but I feared the judgment of my peers. The idea of being hardcore is cool at MIT. Not starting your problem set until the night before, and then staying up all night, is cool. I think if self-care were a little bit cooler, that would help a lot.

Do I wish I'd never had depression? No. I think it has allowed me to be much more empathetic and understanding of other people, and I can be a hard person in some ways. But I'm lucky. My depression has never interfered with my personal or professional life in a devastating way. It's been relatively low magnitude, as depression goes.

It's given me a deep, deep appreciation for people who are doing their best. When I run into someone in a work environment, and maybe they're fumbling through something, or they're having a rough day, or they're not doing so well, it's given me the ability to say, "There are a lot of reasons why that might be happening," and treat them with kindness.

I'm going into general surgery. Being a doctor requires a lot of self-reflection. You're in the mud of people's lives on a daily basis, and having this experience with depression allows me to have some more understanding that life is complicated, and more acceptance of that. Also, when people are dealing with similar issues, I'm always hesitant to say, "Oh, you're depressed?" I never want to assume they're experiencing my experience, but I certainly feel like I'm one of them.

Grace Taylor, Class of 2012, is a medical student at Harvard Medical School.

SAMUEL JAY KEYSER

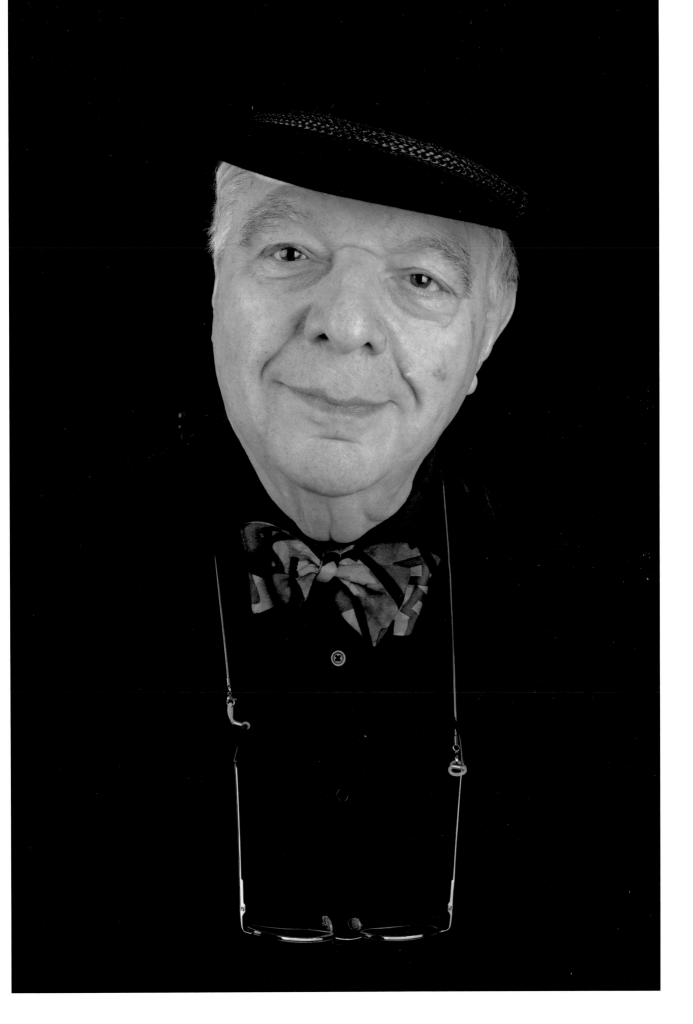

It was the morning of April 26, 2014. I was doing my normal exercises, ones that I'd done countless times before. All of a sudden, my leg just gave way and I fell flat on my back onto a rug. Had it happened to a normal person, it would have simply knocked the air out of them, but it turns out that my spine was not a normal spine. In fact, the neurosurgeon told me that it was the crappiest spine he'd ever seen.

When I hit the ground, my head bounced and compressed the spine. In an instant, my life changed completely. I might have died, but my wife was home and she said, "Don't panic!" and called 911. What I realized much later was that I was rushing toward 24/7 care (for the next seven months), but Nancy was rushing to no help at all.

I have virtually no memory of the next 33 days. I was operated on for nine and a half hours, and there is a nine inch scar from the base of my skull down through my shoulder blades. It got infected, and I had to have another three-and-a-half hour operation.

One week later, a doctor came into my room. He stood at the foot of my bed. He had a clipboard, a stethoscope, he had a name tag, a white coat and all the accoutrements of authority, and he said, "Mr. Keyser, your operation was a success, but I'm sorry to tell you that you'll never walk again."

Now, when he said that to me, what I said inside my head was, "Fuck you." What I said to him was, "I'm sorry to hear that." My wife tells me that when he left the room, the nurse gave him hell for making such a statement, but I can tell you that when he made that statement to me, I never believed him for an instant. How in the world could he possibly know? The only way he could know is because of statistics, but probabilities are simply a complicated way of saying we don't understand. He had no idea who I was or what I could do or couldn't do—and neither, for that matter, did I.

My recollection of the 33 days in the hospital can be represented by five or ten photographs pinned on a cupboard, just flashes of memory. I must have been depressed, but I was never aware of it. Friends would come to visit me at the VA hospital in West Roxbury, and when they would leave, I would start to cry. They had come from the real world, and I was stuck there in a hospital ward surrounded by other wounded people.

I was in the hospital for six and a half months. Looking back on it, it was absolute hell. But when I was living it, it wasn't terrible at all. I was focused on what I was going to do next, how many steps I could take, and meeting all of these goals.

Now I no longer use the wheelchair at home. I sit in a normal chair and I go from chair to chair with a walker. This morning I was sitting at my desk and when the time came to come here, I wondered if I could walk without the walker. So I let go of it and I took three steps. Those were the first three steps I've taken since April 26, 2014.

Look, I'm 80 years old. I've been married to Nancy for fifteen years, and we were together as a couple for ten years before that. I'd been in an unhappy marriage, and now the end of my life was absolute glory. I was constantly telling my friends: who would have ever guessed that the end game would have been the best game? This was a perfect woman for me. We were soul mates; we would travel together, do everything. It was just wonderful, and then this accident happened. The worst thing about an accident like this is that your partner becomes a participant in your disease. If you love your partner, you don't want that to happen.

I can tell you that I wish this had never happened to me, but it is not an unqualified bad that it has. I can go, in my head, to a ward in a hospital in West Roxbury where there are people without legs, without arms, and I can understand what they're going through. It's made me a different human being.

I see a man limping down the street. He's got long hair, he's disheveled, he's carrying plastic grocery bags in each hand, and he's limping. I don't say to myself, "Look at that poor schlub." I say, "There's someone who's found out how to cope." I've learned something that I would never have learned before.

The main reason for my success—if you call this success, and I think you should, as my wife is unfettered, out shopping now, not worrying about me—is luck. Luck, pure and simple. I was lucky to have had an accident in a town where there is one of the best trauma hospitals in the world. I was lucky to have served in the United States Air Force in 1965, which made me eligible to be admitted to one of the best spinal cord injury wards in the country; I was the grand recipient of socialized medicine.

Across the street from me a building is going up. I watched this from the very beginning. I watch them excavate the basement, digging out dirt that hasn't been touched since the ice age. They put up the slurry walls, dig out the mud. Then, they start laying the first floor, then the second, the third, and then they start pouring the concrete. I watch these guys on cranes that are 12 stories high moving huge beams into place. It's just a ballet of excellence.

After watching it for a year, I realized two things. One is that I identified with this building. As the building is getting stronger so am I. Then, I stopped thinking about myself and just started thinking about the building. One day I go online and look for Turner Construction. I want to tell them how good their workers are. I sent an email to the VP of Communication in New York City, saying I happen to live across the street, and I've watched these workers putting up this building. I want you to know that it's been a pleasure. I feel as if I'm sitting every day in the front-row seat of a world-class performance.

Apparently, he sent it to somebody here in Boston who sent it to the superintendent of the building. He emails me and says, "I'd like to give you a tour of the building." I say to him, "Unfortunately, I'm in a wheelchair, but how about coming over to the apartment and seeing the building from my perspective? Maybe you'd enjoy that." He said, "I'd love to." He comes over. He brings me a construction helmet with Turner on the front, an American flag in the back and a label that says Professor Keyser. I wear it around the house.

We're sitting and talking. At some point in the conversation I said, "Mike, how did you get this job?" He says, "Well, the truth is they asked me to be on this job because of the job I did before it." I said, "Well, what was that?" He said, "I supervised the building of an extension to a hospital. It was probably the best building I've ever worked on. There're 28 operating rooms in this hospital," he said. I said, "Where is it?" He said, "It's the Lunder Building at MGH, do you know it?" I said, "My life was saved in one of those operating rooms."

Now, what do you conclude from this? We live in a village, but we don't know it. There are literally 1,000 people who are responsible for my being able to sit and talk to you now in this animated fashion. I don't know who they are to thank.

I'm going to be playing my trombone at Kresge tomorrow night. It'll be my fifth concert since the accident. I've already played a gig up at Plymouth State, and on May 2 I'm playing in a nursing home in Amesbury with a Dixieland band because I want people in the nursing home to see somebody in a wheelchair having fun.

Samuel Jay Keyser is Peter de Florez Emeritus Professor of Linguistics and former associate provost of MIT. He has recently completed a memoir of his accident and recovery, titled A Winged Life; *an excerpt is scheduled to appear in* Washington Monthly.

VICTOR MORALES

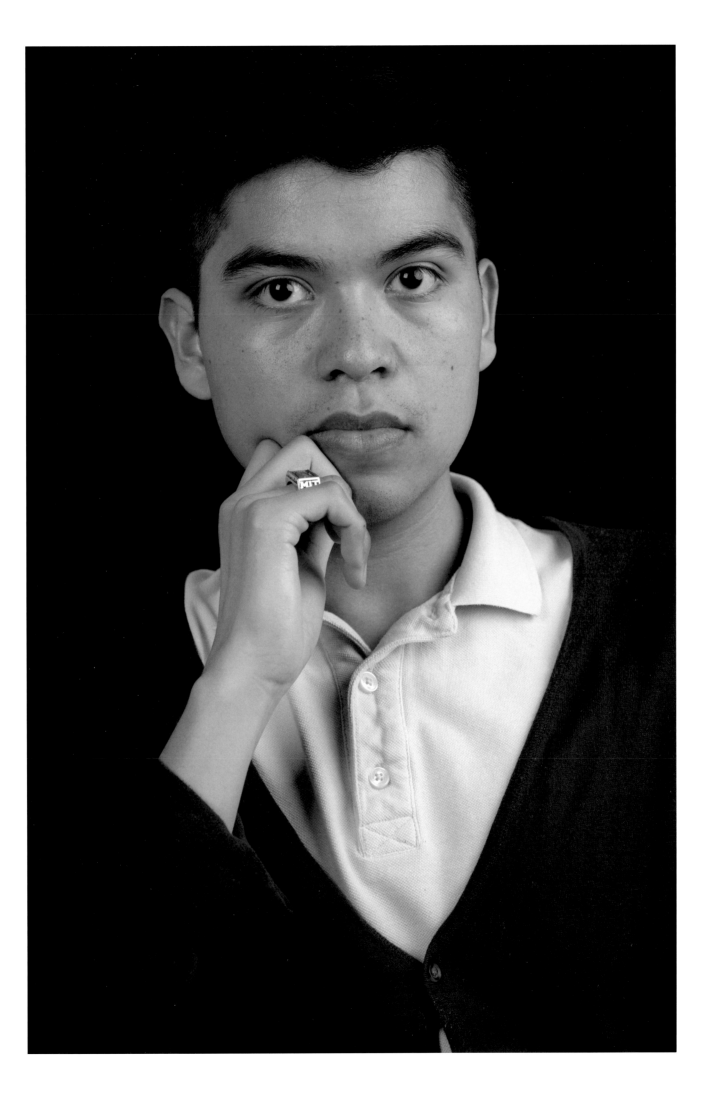

I am an immigrant from Mexico. My mom raised me and my two siblings all by herself. My dad stayed in Mexico. My mom struggled a lot—she never learned English. Halfway through third grade, I was placed in an English only class, and by fourth grade, I was outperforming most of my peers.

I didn't have a lot of friends growing up. I would watch shows on TV with my brother's friends. They would make fun of gay people all the time, so I got into that same homophobic trend. I didn't want to be attracted to men.

I was very overweight. When I started high school, I was weighing myself every single day. I lost about 70 pounds that year. I was hoping people would notice and treat me differently. Girls started paying more attention to me and I made friends. People were still making fun of me that I was gay, but at least I was happier with myself.

When I got into MIT, my mom said, "No, you can just go to the community college here." But when I told my dad, he realized it was *the* MIT, and he said, "Wow. You have to go." When my mom heard him, she of course supported me.

I fit in well at MIT. At the end of my sophomore year, I slept through an exam and failed two classes. I was experiencing my first signs of anxiety. The muscles in my upper body would tense up, and I would want to curl up into a fetal position and not do anything.

My junior year, I ended up having conversations with a lot of close friends who were also experiencing stress in their lives. It taught me an entirely new perspective on life, and it was a great year for me. I was taking a lot of classes and doing a lot of extracurriculars. I had a couple of different positions in my fraternity. I was sometimes leading parts of rehearsals with the gospel choir, I was a tenor section leader of the concert choir, and a member of the chamber chorus.

In my senior year, my anxiety came back. I went to office hours one day. The professor was asking me questions, but I didn't understand, so I just froze. He said, "I think your IQ went down when I asked you that question." A lot of thoughts were flowing through my head, like, "Why did I come to office hours? I'm so stupid. I don't belong in this class. I don't even belong at MIT." I'm walking away and I'm sweaty, and tears are starting to form but I'm trying to hold them back, and it feels like I'm swallowing all these tears. As soon as I exit his office, I just start crying and crying.

Another time, I was working on a project with an instructor from the Scheller teaching program. She kind of just shut me down and said, "Wow, you've spent so many days, and you don't even have a concrete question? What have you been doing?" I'm now a licensed high school teacher, and I've taught students who are immigrants, who are working two jobs to pay the bills and who come to school and they're falling asleep. I would not dare ask them the way she asked me, "Why is it that you haven't been doing your homework?," especially because she didn't understand that I was depressed.

It was a very, very difficult year, but I graduated. I joined Teach for America and started Summer Institute, but it was as though MIT never ended. If I turned in a lesson plan at 1:00 a.m. instead of midnight, they'd sit me down and tell me it was a breach of professionalism. I didn't understand that I was going through mental-health problems. All I knew was that I needed sleep, and I hadn't even caught up on the sleep deficit from my time at MIT.

By the end of the summer, I had been hired to teach at a charter school called KIPP Academy in Lynn, Massachusetts. My coaches were saying they were going to tell my principal that I was underperforming. I started teaching at KIPP anyway, and I enjoyed it. It was rigorous, and I felt very challenged. But a couple months in, my principal told me, "Hey, the Algebra 2 teacher left, so we need someone to substitute."

Nothing could have prepared me for stepping into that classroom. The kids were so frustrated that they had had different teachers coming in and out, and their teacher had just disappeared without notice. The first day the kids told me, "Mr. Morales, you're not going to be able to get our attention." It would take a good 15 minutes at the start of every class for me to get them to be quiet. The students who wanted to learn were frustrated because they were already so behind. They thought I was a joke. It was out of control, and that was very, very stressful. My principal ended up sitting me down, telling me "It sounds like a very difficult experience, but you can, Victor, you can do this."

That made me feel terrible. For all I tried, I just couldn't do it. She would tell me "Victor, these are all the things that need improvement. Such-and-such kids walked in late. Such-and-such kids were talking when you were talking." Every time, I came out of her office feeling like I wanted to vomit. I would shut myself into the bathroom for a couple minutes just to breathe, just to cry a little bit.

I was taking days off work because my anxiety was so bad. My principal said, "You need to come to work every day no matter how you feel. All of us here," and I remember her looking at the assistant principal and them nodding heads to each other, "All of us here have experienced some level of what you're experiencing." I had told her that I was going through mental health problems. What she said belittled my experience and made me feel like I was being whiny, that it was a small thing, so it just made it so much worse.

I fell in love with the kids, and I built great relationships with the staff. But by the end of the year, I was having an anxiety attack every single week, and I just couldn't take it. I knew I couldn't keep teaching at that school, and the principal ended up not inviting me back.

I found another job at a school called Boston International Newcomers Academy. They had an old building, and the hallways weren't the cleanest, but the culture was so warm. The teachers made me feel so valuable, even on day one. All the students were immigrants, going through challenges like the ones I had experienced. They were so polite, respectful, always happy to see me. I felt so proud, so privileged to be their teacher.

It was the end of October last year when the depression came back, and it came back many times worse. It was like I woke up one day and felt numb. I couldn't feel as much as I had felt the previous day. For an entire week, I sat there at my desk and could not do anything.

I had an ever-growing stack of papers to grade, and my kids kept asking me about them. I would say, "I have a lot of things going on. I'll try to do it by this day, but no guarantee." They were like, "OK, Mr. Morales. We understand." I would smile because they were so nice to me.

I was sleeping twelve hours a night. I couldn't eat anything because I couldn't get hungry. I couldn't even feel sad or sorry for myself. There were days when I had to call a friend and ask them the silly question, "Can you come and pull me out of bed?" They would do that.

It wasn't easy to explain. People think that there has to be a reason for depression. They would ask, "Why are you depressed? What happened?" I didn't know what to say. Nothing really happened. Depression just kind of came back, and it came back at a point in my life when I was so happy. I loved my students. I had a very good job.

Depression stole my life. It stole my desire to live. It came down to me asking, "Why should I be alive if I can't feel anything? Why should I be alive when I'm just this zombie?" Things got worse. I applied for medical leave and was denied. Then I was terminated because I had missed too many days. I struggled financially, and my medical insurance ran out. I started seeing a therapist and taking Prozac, but it just made me feel more numb.

There were a couple of occasions when I asked my friends whether I was alive or not. I thought maybe I had died. Hurting myself was the only way to try to release my soul from this dream. If I could at least feel extreme anything, it was such a relief to know that I could feel something. But when I would hurt myself too much and see the scars on my body, I would think that I was lost in my depression, that I didn't know who I was anymore.

By December, I had built a set of strategies to overcome depression. For anxiety, what worked was to clear my mind—by watching a BuzzFeed video, meditating, or having a conversation with a friend. Depression was a totally different beast. To overcome it, I had to develop meta-cognitive strategies. The first step was to convince myself that life is worth living and then choose to live.

I already had this sort of plan to take my own life, but I couldn't stand the idea of taking my own life and setting up my friends to experience a tragedy of this kind. My friends were taking me out to lunch and dinner, spending three, four hours with me, talking about me and me and me all the time. They had become a reason for me to live. How could I take my own life when so many people had invested so much in me? So many people saw—I don't know what—in me, and I guess they cared or loved me. In that way they communicated to me that they thought it should be worth it for me to survive.

One day I discovered that at the source of my depression was this idea that my greatest value came from the way others saw me. I cared if other people saw me as ugly or attractive, as intelligent, as smart or dumb or stupid. I cared if I was a successful teacher or not. One of the solutions, if the problem was that I thought I was unattractive, was to convince myself that beauty is only a relative term. If someone now makes me feel stupid, I say to myself, "I interpreted their tone to be demeaning, but they probably don't intend to make me feel bad." That makes me feel so much better.

I identify as bisexual now. When I went home for the holidays, I told my mom that I'm attracted to the same sex. She started asking me all of these questions about the Bible and about what I'd done. She wasn't asking me in a loving way. With my dad, I'm taking it more slowly. I feel like if I tell him what I'm doing he's going to misinterpret it and get upset at me, so I want him to first understand what I believe. He's a very understanding person.

Because I wasn't able to get my job back at BINCA, I'm working as a tutor at The Academy at Harvard Square. I'm also working at the Edgerton Center at MIT, and I'm applying for a number of different jobs for next year. I'm off medication, and I'm no longer seeing my therapist. I haven't had anxiety in weeks—months, even.

My biggest stressor now is my finances. I'm thousands of dollars in debt because of medical bills. The stress I get now is very mild. Maybe it's the kind of stress that most other people, who are not going through mental health issues, feel.

I still identify myself as depressed because I understand that depression can come back at any point. I have to be ready. I've thought about giving gifts to my friends who helped me survive. But there's no need. My life from now on is a tribute to those people who showed me love. I hope my story can help others in a similar way.

Victor Morales, Class of 2014, is a high school educator.

EVA BREITENBACH

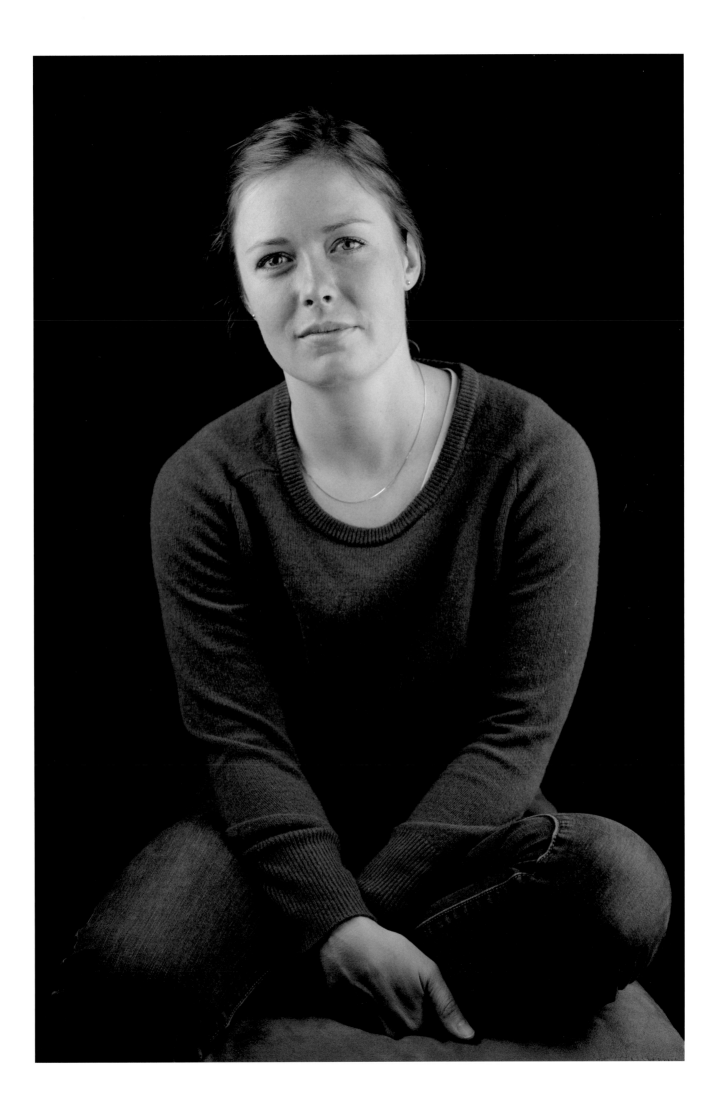

Anxiety and stress are things that I have dealt with for a while. Starting business school was a particularly stressful time for me, because I was trying to figure out what I wanted to do with my life, and I had some doubts about whether business school had been the right decision for me.

I thought I was dealing with it relatively well. Then, in the last week of November, I went out to dinner with my boyfriend. We got in a huge fight, and I woke up the next morning and couldn't move half my face.

I knew as soon as I woke up what was going on, but I tried to convince myself that I just pulled a muscle. But I couldn't even drink coffee or eat without leaking out of the side of my mouth. Eventually I went to urgent care, and they told me I had Bell's palsy. They said it should go away in two to six weeks.

I was shell-shocked, utterly overwhelmed, didn't really understand the implications, and felt scared and helpless. As a young and healthy person, there have been very few times when I've felt like my body betrayed me. This was a real sign that my body had done something that was not under my control, and I didn't know what to do about it.

In that first week, it got worse and worse and worse. I started feeling a lot of pain, and my face froze up more. I was getting stiffness in my neck and a rash on my ear. It turned out to be four whole months of no motion at all on that side of my face.

The really hard part was feeling like I couldn't communicate with the people around me. I'm pretty quiet, but I tend to smile a lot. My smile would be like a grimace, and it wasn't recognizable as a smile. It made me hugely self-conscious, so I generally didn't make any expression, because if my face was resting, you couldn't tell that anything was going on.

So I basically stopped smiling at people. I came to realize it's a fundamental way that humans communicate with each other. There's a lot of research showing that the more that you smile, the more that you are actually happier and feel joy. Not only was I struggling with this stressful thing, which was caused by stress, but the way that it was manifesting was causing me even more stress. It was really difficult. I just went inwards a bit. I stopped going to social events, and I ended up spending a lot more time alone.

It got even harder when I started hitting the timelines when people had told me I should be getting better. There are far worse things than not being able to smile, and I had to accept that I might never get better. It's an interesting disease, because it's only cosmetic,

and when you compare it to things that other people are dealing with, it's so clearly just not even on the same scale. But, at the same time, it was real for me, and it was challenging how I saw myself both figuratively and literally.

I was finally made to engage with it, and recognize what it had done to me, when the Sloan School had a storytelling event called "The Yarn." I signed up. I realized that Bell's palsy was not under my control, but my reaction to it was under my control. I could decide whether I wanted to see it as this horrible thing that I should feel sorry for myself for, or as this opportunity to better understand myself, and to derive meaning and purpose.

Once you start to see it in that way, it changes a lot. I started to see that there had been really good things about me having to step back from all the craziness at school. It had been a way for me to gain more clarity about what I actually cared about and what I wanted to be spending my time doing. I realized that I hadn't been living in line with my values. In business school, there's a lot of pressure to follow the herd. I'd been pulled away from the things that I really wanted to be doing, such as art and writing.

So it was a wake-up call. It's easy to just think you can deal with stress. You take on more and more and more things, and think it will all work out somehow, sleeping five hours a night, running from activity to activity, saying yes to everything because you don't want to miss out on an opportunity. And then you realize that you're no longer a person. You're just a to-do list, and you've lost touch with who you are and what you want.

I started meditating more regularly. I had been doing it intermittently before. I got my emotional house in order, and lo and behold, the movement started coming back in my face. I sent my boyfriend a video right away. I could just move the corner of my cheek, my lip at first, and then over the course of about three weeks, I regained a lot of movement and sensation.

There are a lot of paradoxes in what happened to me. In many areas of my life, I have this tendency to try so hard, and when I see a problem, I say, "I'm not going to give up. I'm going to keep going. I'm going to keep pushing. I can make it through this. I can figure out the solution." But sometimes you have to just step back and breathe, and say that maybe this problem can't be solved, or maybe I need to take a break from it and come back later, or maybe I'm so

fixated on this specific problem that I'm not realizing it's irrelevant to the overall bigger picture.

This is maybe a little bit of the Buddhist in me, but I now see there's a difference between the emotion you feel and the story you tell yourself about it. I can say I am feeling overwhelmed, and I can focus on that feeling of overwhelmedness, without launching into the story about, "Oh, I'm overwhelmed because I'm never going to get better, and this is going to be this thing that I have to deal with for the rest of my life." Instead I can say, "Hey, I feel overwhelmed right now. Let me do something to relax."

I'm at six months now. I probably won't regain full capacity. If I try to raise my eyebrows, I can only raise them on one side, and my smile isn't symmetrical anymore.

But it's funny how when I look back on this year, Bell's palsy was probably the best thing that happened to me. It was this really powerful clarifying force. Before I would get so caught up in my emotions. Something would happen, and then I would have this huge emotional response to it, and that would be my reality and I couldn't get out of it. Now I have some distance from my emotions. I can make choices.

Eva Breitenbach is an MBA *student in the Sloan School of Management.*

JOHN BELCHER

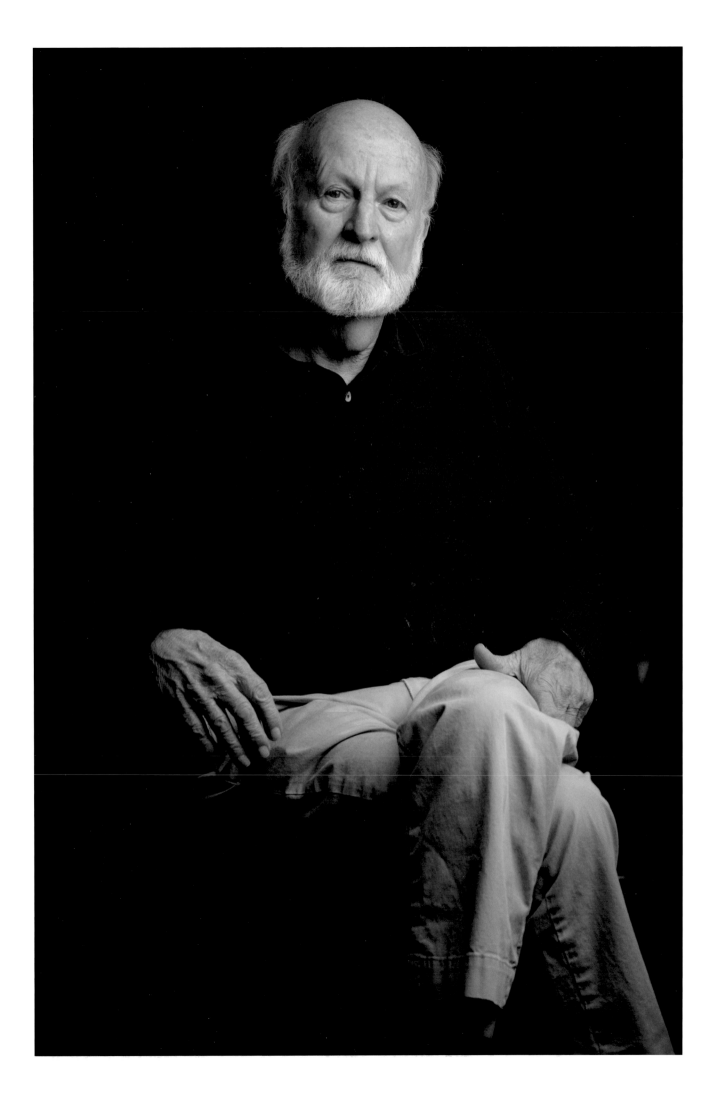

I knew I was in bad shape, that I couldn't handle this myself. You keep going over and over in your head how to solve things, but I had so many problems, the whole system just broke down.

Being clinically depressed, you can be in extraordinary pain. Just existing can be painful. It's very hard to see that other people are struggling with the same things. Part of the downward spiral is this feeling that you're not making it here, you shouldn't be here, that you're not worthy of being alive.

If you're clinically depressed, sometimes your cognitive processes are impaired. My favorite example is that I could not recite the Pledge of Allegiance. That's something that anyone can do. But whatever was going on chemically in my brain, when I would try to recite something by memory, I could not do it.

What I didn't realize was how important it is to be involved with people. Depression happens when you get stuck inside your head. You have to get out of your head, because your head is a very strange place. If you're connected to other people, it allows you to get more perspective on your problems and to get away from the things that lead to this downward spiral. It's a much better way to live.

I'm asocial, in the sense that many physicists are. I would rather be sitting in front of a computer screen than interacting with people. I always did very well in school, and that was how I accomplished things. I was just more interested in abstract ideas than people. Dealing with people was not painful, but it was always difficult. I still have trouble calling people I don't know on the phone, and I'm 72 years old.

Yet having been depressed has been a major positive for me. It's one of these things, if you live through it: difficult times make you grow. My motivations have changed—what I think is important. My priorities are more oriented toward people as opposed to doing scientific projects. I still enjoy sitting in front of a computer at the Linux command line. That's what I used to do all the time. Now I'm a little more multifaceted.

I'm happy with the progression of my life. I'm very lucky to be a faculty member here. I don't think I would've done that differently, but I'm glad to have a different perspective on things now.

There's a whole mindset here at MIT that is very ambitious. It's very hard to break through that, unless you have some personal crisis. We tend to be asocial, off building something in our closets that we'll bring out and impress our colleagues with. They'll go, "Oh my God, that is so bright; I don't know how you did that." And you'll say, "Oh yes, that's right, I'm really bright."

One of the things that was good about my travails was that if I hadn't had them, I would have been trying to climb that ladder until the day I dropped dead. In some sense, I am still trying to climb that ladder, but it's balanced by a realization that there are much more important things, like being able to walk and get out of bed in the morning.

I was raised as a Southern Baptist, but I decided I was an atheist at the age of 13. So I'm not into religious interpretations. Let me take that back. When I had the melanoma, and my children were 8 and 11, I made deals with every god that I could think of. If they would just let me live until my kids got out of high school, that would be enough, and I would be devout the rest of my life. Of course it didn't happen like that, and my kids are now 35 and 38. The most spiritual I've ever felt was sitting in support groups where people are sharing anonymously, where you don't know their names, and they're talking about things they're going through. That's the closest I've ever felt to being spiritual. I never felt that in a church.

One of the reasons that MIT is the way it is is that we tenure based on outside professional reputation. There are a lot of things that follow from that that are not good, but we've made the choice, and I would not make a different one. Some of the uniqueness of MIT comes from that choice. And it means that some faculty are wonderful human beings and some aren't. We have a really excellent institution. There are bad things about it, and I'm not quite sure how you fix them, because some of them are the same things that make us excellent. So it's a real conundrum.

John Belcher is the Class of 1922 Professor of Physics.

EMILY TANG

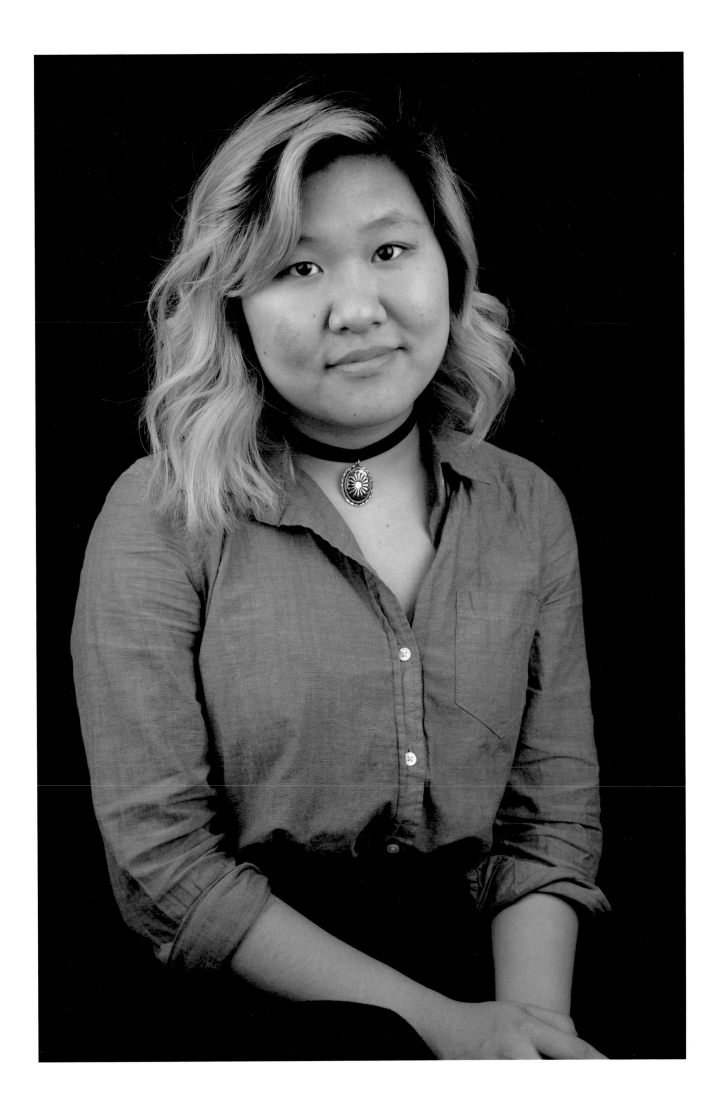

I grew up in a suburb of Dallas called Plano. We're on the back of every pack of Frito Lay chips, because that's where their headquarters is. There are three really good high schools in Plano, and I went to one of them.

In eighth grade, I started getting pressure from my parents, especially my mom. I like taking classes for the sake of learning. When I'm doing things just for the grade, it drags me down. I would get a bad grade, go home, and I wouldn't say anything. Internally, I would be beating myself up and I'd be really upset about it. From my mom's perspective, it looked like I didn't care.

That was when I got my first bout of depression and started to withdraw. I didn't sleep much and I wasn't eating well. I would stay up late at night talking to my one really good friend. I had a lot of pent-up emotions, and my mom would get mad at me if I cried. I started cutting myself—sometimes to feel something, and sometimes to punish myself.

I still remember all the numbers, because that's how important it was. We were fighting for those points. There was so much pressure to always get in that top bracket. Early on, if I got a 90 or above, I was good—that made an A. But then I needed 97 or above, to get an A+.

In tenth grade, I befriended someone who turned out to be a pathological liar. She made up a whole cast of characters. The main one was a pianist who was her partner. She would use fake online accounts, and she had him pretend to fall in love with me. I was really naïve. While they were supposedly in Chicago at a music competition together, she told me he'd gotten into a car accident and was in the hospital. I spent a whole year listening to her stories and believing her. She was my best friend, after all.

I was getting suspicious though. I have a really good memory, and things started slipping through the cracks. I started noticing mistakes. I did a little bit of behind the scenes snooping, and I hacked her accounts. I was still in denial though. Eventually, my mother found out. She called the girl's father and asked him straight up whether this person existed. Her dad said no. There was no competition and no such person.

After it was over, I fell into a depression. I started withdrawing from my friends. I tried to talk to my mom about it. I said, "I think I'm depressed. I'm showing all the symptoms. I'm having a really hard time." My mom said, "You're going through a hard time, so

you think you have depression. There's no history of it in our family." I come from an Asian American community. In China, mental illness is still stigmatized. They're only just starting to acknowledge that it exists. It's very much, "Pick yourself up off the ground. You can just get through it. It's all in your head."

I was in the top ten of 1,100 students in my high school class, so I ended up applying to MIT. Coming to MIT, everyone has that stumbling block where you were the smartest person in your school and you're so used to being on top, not having to study because things come to you quickly. You hit MIT and it's not enough anymore.

It was so crushing. I remember taking biology freshman year and getting my first exam back and being hugely disappointed. My mom called me right after, because she knew I'd taken a test. I didn't want to tell her my grade, I was so upset about it. She kept pushing, so I told her, and we had a fight. I was crying when I hung up the phone. One of the upperclassmen came over and hugged me and was like, "I don't know what's going on, but I figure it's Asian parents."

By the end of that first semester, I was already slipping and not going to classes as much. I spent the winter break doing a web competition. You learn basic web programming and you make a website with a team. I did it with some friends for fun, but at the end, to get the website running, I had to rebuild the whole thing from scratch. I spent an entire night fixing it, which screwed up my sleep schedule.

Right after that, the semester started. I had declared early sophomore standing, because I had a bunch of AP credits from high school. I did it so I could take five classes, which was a bad idea. I basically backed myself into this corner where I'd convinced myself I couldn't drop any class.

I stopped going to class in the second week of the semester. This was February in Boston, and every day was gray and cloudy. I spent days just wandering in a haze between my room and the lounge spaces. When I'm depressed, I have really bad insomnia. I'll stay up until seven or eight in the morning. Dawn comes up and birds are chirping. Then I'll sleep a ridiculous amount, or I won't sleep at all.

I had really good friends who took care of me. I was barely feeding myself. They brought me food and said, "Eat this." They made appointments for me at student services and mental health, walked me to all my appointments, sat outside waiting, and then walked me back. That was such a big thing.

I spent six or seven weeks bouncing back and forth between student services and mental health. It was really frustrating. This is the part I usually don't share if I'm giving pep talks to groups. I don't want anyone to be discouraged from going to student services or mental health just because I had a bad experience. It's already discouraging enough.

A dean in student services mentioned a partial program, where I would be doing a hospitalization during the day and taking classes in the evenings. Every time I went, I'd ask, very timidly because I was full of depression and anxiety, "This was a thing that I heard about. Maybe I can do it?" After six weeks they finally said, "Oh, you can't do that. There aren't any classes that would allow you to have such a schedule." The first doctor I saw at MIT was convinced I was in an abusive relationship. When I finally convinced her that wasn't the case, she said, "Do you want to be hospitalized? Do you want medication?" I said no because I wanted to make it work without going on leave. She said, "It sounds like you just need to go to class."

I switched to a new person. Every time I went in, she gave me a depression survey to fill out. Then she'd tally it up. "Looks like you're pretty depressed. We're a little concerned about you. I'll see you next week." Eventually she sent me to somebody to prescribe medication. This woman just homed in on the idea of me having bipolar disorder. She put me on an antipsychotic. It didn't change anything.

In the middle of the spring term, they told me I had to go on leave. March 14 was the day I left. I remember the irony: it was Pi Day. All across the nation, everyone was being told they were getting into MIT, and I was leaving. They called my mother and told her I might have bipolar disorder, which really scared her. My mom ended up flying up here, packed up my stuff, and then we flew back down to Texas together.

In retrospect, it was the right decision. I just don't appreciate the way it was forced on me. Most of MIT's leaves are voluntary, but that's because the alternative is they put you on an involuntary leave, and that's even harder to come back from. What choice do you have?

It felt very harsh, because my whole support network was here in Boston. I was afraid to go home because my mother was not going to be sympathetic. I didn't want to face the disappointment, to have tangible evidence that I'd screwed everything up and was back where I'd started.

So I went home, and I spent a while hiding out. I was going to group and individual therapy. We were

all ashamed. My parents were ashamed, and I was ashamed of myself. People saw me, and there were a lot of awkward questions. I spent a year not telling anyone, except for my closest friends, what had happened. I withdrew from social media. Basically, I disappeared.

On May 20, I came back to Boston. They were wrapping up finals week. I found a job at a summer camp for Brazilian kids. It paid enough to cover rent for three months. I took classes in chemistry and linear algebra for six weeks, but stopped going halfway through, so I got Cs.

I had a psychiatrist back home in Texas who I saw when I was there. I was still in a funk, so I talked to him and he prescribed me Fluoxetine. I thought medication might help fix this funk, because I couldn't seem to get it to go away myself. But I was more depressed than ever, and it didn't help. Later, he told me that my problems with my mother were entirely my fault. Driving home from that appointment, I had to stop my car on the side of the road. I was on the phone with friends and listening to this song that kept repeating "Please don't go, I love you so." I had to calm myself down and shut all my thoughts out. I wanted to drive the car off the road. I never saw that psychiatrist again.

My mom wanted me to come back home for the fall, but I didn't want to. I struggled my way through finding an apartment in Boston. I convinced my mom to let me stay for another year. I took a job at a tutoring center, and then I worked at the Harvard Book Store for a while. I took classes at Harvard Extension the entire time.

I went back home for winter break and had a big fight with my parents. They didn't seem to understand. To them, I was ruining their personal stake in my life. I was like, "Don't you understand that this is my own life? I care about it. I care about this so much." They were yelling at me for things that were already tearing me up inside, and it was too much to bear.

I walked out of the house. I spent hours wandering the neighborhood. I saw my parents drive by several times but I hid from them. It was raining and I was freezing cold. There was a giant lake, and I wanted to walk into it and drown myself. I was on the phone with the guy I was dating at the time. He convinced me to walk back to the house. I went back, and they were just like, "Go upstairs. Take a shower." I went upstairs and cut myself in the shower.

That was the last time I ever cut myself. My parents still don't know I was doing it. Even now sometimes

when I'm going through a tough time, when I'm really depressed, I'll think about it. But I've promised my sister and some friends that I won't ever do it again. Over time I've shifted to healthier ways of coping, such as writing angsty poems.

After that, I think my parents slowly started to realize just how much I cared. I don't know why it took them so long. My mom was telling me, "I was talking to your dad on the phone and he said maybe Emily really does care about this a lot." I was like, "Yeah. Really? You don't say."

In the fall, I applied to return to MIT in the spring semester. My dean in student services was supposed to help me, but he felt more like a goalkeeper, standing between me and getting back in. I felt like every time I went to an appointment with him, there was this unspoken list of questions that I had to know the answer to, and I was giving all the wrong answers. I was never going to be able to get back in.

My application was rejected. I applied again the following June. They tell you in August whether or not you got back in. They don't give you any time to sort your life out. I didn't get back in that fall either, so I moved to another apartment out in Somerville where the rent was cheaper. I started new classes and got a new job working at a tea store. That semester was so much better. My co-workers were great and my boss was supportive. I was taking classes that I enjoyed more. I felt a lot better, and things were looking up.

I reapplied for the following spring and I finally got back in. So here I am. I joined Concourse, a great program that has smaller classes and a tighter community. My semester was super tech-heavy, which was kind of sad, but I got through it. I volunteered to run Campus Preview Weekend for my dorm. That basically ate my life from the end of February to the beginning of April. I went into a little tailspin at that point, and I broke up with my boyfriend. I had a really bad bout of depression for the last three or four weeks of the semester. But I more or less caught up, and I made it through in the end. I passed all my classes. I made it through. I'm still here, and next semester's going to be really great, probably.

I've learned that you need to find some other passion. Everyone here is good at academics. You've got to find something else that makes you happy, and makes you proud of yourself. Otherwise, if your academics go wrong, what else do you have?

No matter how much you love learning, love the material, there's always that time when every class is giving you crap and you have exams and essays due the next day, and you start wondering why you're doing this. At that point, you start to lose sight of why you want to do it all.

My mom has come to understand me a bit. Our relationship has changed and improved so much. That's probably one of the best things that has come out of all of this. She's not a villain. She put it all on the line for us. She was going to be a tenure-track professor in Virginia, but she wanted a place where my parents could be together to raise me and my sister. They chose Plano because it was a good school district. She ended up taking a job as a professor at a community college, just so she would have hours that matched me and my sister better, so that she could be there for us. The reason she yells at us is because that's how her parents raised her. She just wants us to have a better future. That's how she shows her love.

I grew a lot in the last few years. I learned the importance of being able to do things on my own. I spent a lot of the first year and a half of depression being very dependent on other people to pick me up when things were falling apart. I'm not saying that if you're horribly depressed you just need to get over it and pick yourself up right away. Not everyone can do that. You need other people to be there for you. But at some point you need to wean yourself away from relying on other people and learn how to do it yourself.

The way you get past depression and anxiety is you act against it, with the help of whatever medication or therapy you may need. It's the hardest thing in the world, because your brain is telling you, "Keep hiding in your corner. Keep staying in your bed. It's not worth it. Don't get up. Don't do that." The only way to get through it is to get up, get out there, go against what it's saying. When anxiety tells you, "Don't go to class, they're all going to judge you, they all think you're stupid," you have to just open the door and walk in.

That's such an incredibly hard thing to do, because everything in your body is screaming at you to not do it. When you reach the point where you can do that yourself every single time, when you're able to consistently beat it, that's when you reach equilibrium.

I'm nicer to myself now, which is big. Now it feels less silly to take selfish time for myself. I'm better at fighting the anxiety monster. I'm better at beating the depression. I'm not perfect at it. But considering the fact that I got to half my classes during the three weeks I was depressed last semester, I think I did OK. If this had been two years ago, I wouldn't have gone to any of

them. I would have just disappeared off the map. This time, half the days I was able to fight it off, to crawl out of bed, and drag myself to class. That means something, right?

Emily Tang is a member of the Class of 2019.

TYLOR HESS

The first time I got a B in my life, I broke out in tears. That was in Mrs. Griffin's fourth-grade reading class, and I never got a B again until I came to MIT. She hoped a B+ would motivate me, but instead it crushed me and was a traumatic experience that I remember to this day. I was in the gifted program. I cared so much about grades, I was pulling all-nighters in elementary school.

It wasn't coming from my family. They rejoiced that night I came home and cried about my grades, and lovingly joked "Finally! Proof you're human!" They even baked me a cake. My family is one-in-a-million. My dad showed us the value of hard work, commuting three hours a day so we could grow up in the picturesque Pocono Mountains. You couldn't find a more loving and caring mother. In her eyes, my three brothers and I could do no wrong.

In high school, I really cared about grades, and when I got good grades it was super rewarding. In college it was about the grades but others things, too. I won 21 scholarships in four years, studied abroad in Spain, and was a two-time national medalist in Taekwondo. For me, these were memes I collected—like the time I did 24 drinks one night in my fraternity.

Motivation used to be in infinite supply for me. Then, suddenly, I had a very finite amount of it, and it was hard to get anything done. The things that used to bring me pleasure didn't bring me pleasure anymore. Routine tasks, like doing a problem set, became paralyzingly overwhelming. At other times, I felt desensitized to stress, like the main character from Office Space who is permanently stuck in a hypnotic state. I felt numb to things that actually mattered, like graduating or finding a job. On top of this, I felt guilty, too—that I was disappointing my parents, not living up to my MIT education, and letting down my younger self.

I was taking a course called "The Supernatural in Music, Literature, and Culture," and we read the story of Faust. The devil tried tempting him with everything—fame, fortune, money, power, intellect—but he was never really happy. It made me realize that all the things I'd valued ultimately left me feeling empty inside.

One night in my senior year, it got so bad that I jumped off a bridge. Growing up, I had done some cliff jumping, and I was pretty sure it was safe. I had scoped it out the summer before with a friend, and we went down in the water as deep as we could to check it was clear.

I had been thinking about jumping off for a long time. When I did it, it was a spur-of-the-moment decision. I was apathetic, and I just wanted to feel something. Because it was a really warm day in the spring, I didn't think about the temperature of the water. Fortunately, I'm a strong swimmer. Otherwise, I'd have died of hypothermia. By the time I got to the shore, I was a mess. I had numb limbs, slurred speech, tunnel vision, and had stopped shivering, which is a very bad sign. In retrospect, it wasn't a very smart thing to do, and it didn't help anyway.

I graduated from MIT in 2010, in mechanical engineering. At that point I was pretty burnt out, but my momentum from good grades and other memes carried me across the finish line. One of my friends offered me a job at Booz Allen Hamilton. I wasn't super happy there, so I took the first opportunity I had to leave. I went to work with one of my old professors, who was starting a university in Russia. I wasn't happy there either, and I was, like, "Maybe I'd like to do research." So I came back to MIT and joined a research group, but that wasn't my thing either. I took a year off and worked for some startups—all these world-class opportunities that some people would probably kill for. But I still wasn't happy, and that's when I realized it wasn't the external things.

So I took a year off, dropped all my responsibilities, and started practicing yoga. I did a yoga teacher-training program, and became interested in Buddhist philosophy. I was raised Catholic, and one of the things you hear is, "You're created in God's image." There are many different ways of interpreting it, but one way I heard at a Bible study group was that it's like a glove with a God-shaped void inside. I feel that void, but I'm not sure it's God that fills it.

One of my Christian friends at yoga suggested reading the Bible but replacing every instance of God and Jesus with the word love. So what fills the void is being part of loving and supportive relationships. You see that the people who are into their faith are the ones who are part of a community. As an atheist, which is true of many at MIT, it's really easy to be, like, "God doesn't even exist, how could God fill the emptiness?" They don't see that, for these people, God is a loving and supportive relationship.

Even if you have that insight, you can't just snap your fingers and make it happen. Since coming back, I've sought a community at MIT with those relationships. I never found it here, but I found it through meditation, through yoga, and other friends outside of MIT.

In my judgment, a lot of people at MIT are ignoring this fundamental human need for connection, fellowship, and companionship, but they're completely unaware of it. The easiest way to be unaware of something is to distract yourself. MIT is a built-in distraction.

MIT is like this giant monster. Every single individual you interact with is helping you to fight it: all your peers, all your professors, even the administration. It's not just MIT. MIT epitomizes American values. MIT is meritocracy, which is institutionalized success and achievement. If you question that, and wonder if these things are vices, very few people would agree with you.

I had a conversation with a friend last night. He used this term, which I really liked. He said, "We're in a small group of engineers whose hearts have softened." He's going through the same struggles I am.

Tylor Hess is a graduate student in Mechanical Engineering.

LYDIA KRASILNIKOVA

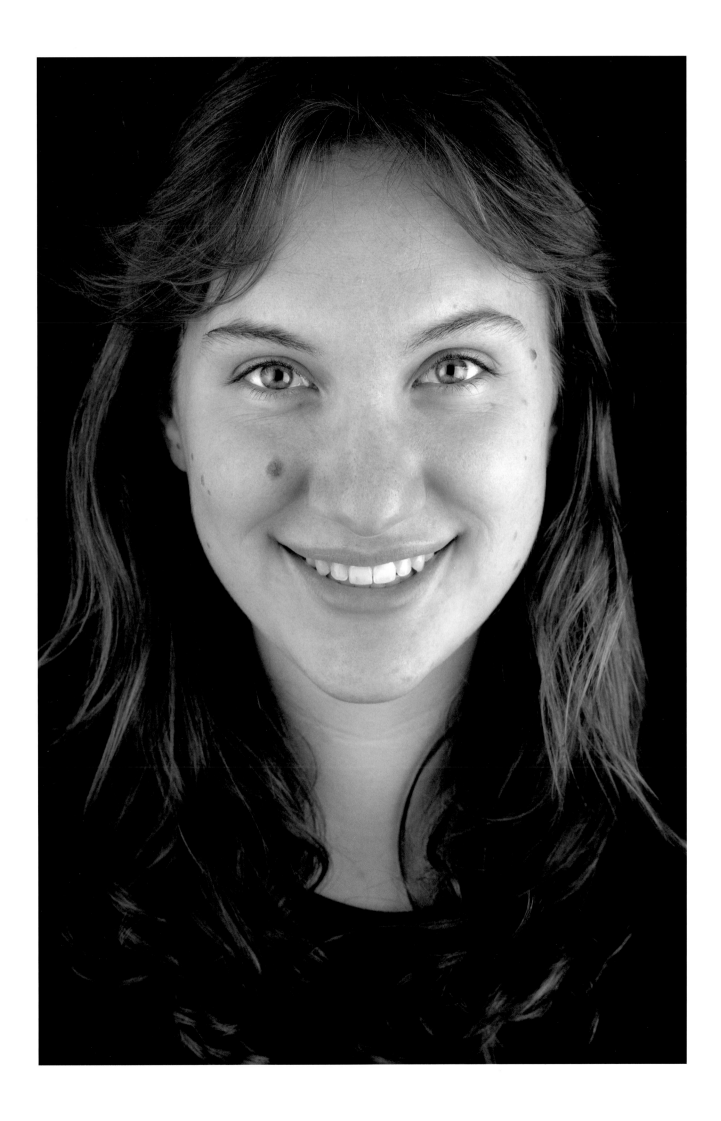

It was October 29, 2012. My research wasn't going too well, and classes were taking up all my time. I was very stressed out and unhappy, and I wasn't exercising or sleeping or eating right or socializing very much. I was miserable, and my boyfriend and I had a big fight and almost broke up. It was very dramatic.

I went over to visit my friend who goes to Tufts, where they have a lot more trees. In the dorms at MIT, we work adjacent to each other like parallel play when you're kids. At Tufts, I was amazed because people were just hanging out. Not with their laptops in front of them, not doing a little work in the background. Oftentimes at MIT, when you let yourself hang out, you still have a cloud looming over you of some unfinished task. There's a lot of guilt associated with just hanging out. They didn't have any guilt. It was just joyful, blissful happy hanging out. It was so bizarre to me. It was so lovely.

I wrote a blog post titled "Meltdown" saying I'm hoping that this is all worth it because I came here to build myself into something better. But it really did feel like I was being stretched very, very thin. The response was incredible. A lot of people commented and emailed me, especially alums, and especially people I'd looked up to that I didn't know had noticed me.

Shortly after, I lost my job and my grandfather died. Then it felt like when I wrote "Meltdown," I had had everything back then. My parents had me young, so I spent a lot of time with my grandparents. Even after we left Russia, my grandparents on my mom's side visited us every summer. My grandfather was diagnosed with cancer before I came to MIT. I did not think for a moment that he would die. The last time I saw him, my mom and I went to Israel, where he was in the hospital, to spend time with him for a week.

It was actually pretty astounding. He'd lost the ability to speak but, for that week, we got our own little miracle. It was as if he was healthy. He spoke, he could walk around—it seemed like he was better. It was probably very positive for him that we came to visit. It probably made him feel very loved and cherished, and that probably does wonders for fighting cancer.

Anyway, I had brought a stack of papers for a job, and I was reading these papers instead of fully dedicating myself to spending time with him. That is absolutely one of my biggest regrets. That job led to nothing. It doesn't matter what I sacrificed. It wasn't worth it, not even a little.

It's so important not to prioritize career over family. You don't realize what people are doing in your life,

what roles they're playing, sometimes, until they die. And you don't know what you are holding together in other people's lives. You might not know that you are the glue holding together so much, because you take yourself for granted, just like we take other people for granted. Before my grandfather died, he had been holding together so much. I had no idea.

Anyway, all of that fell apart. I felt like I had lost everything. I think that's the lowest I've been. I don't think I will ever get over those things. I'm OK with that. I certainly think I'm happier now than I have been in a very long time. I have more free time, and I have a rewarding job doing research that is going to have an impact on people's lives. There will always be times when things are really bad. The bad things pass, you survive them, and move on, and you get to experience awesome things down the road.

The mind is like a forest floor. The more you walk paths, the deeper they get, and the easier it is to walk them again. When I wasn't doing so great, there was a path falling into unhappiness, and the more I walked on it, the deeper that path got. It's important to learn how to tell yourself, "No, I'm not thinking about that right now. As a matter of fact I'm never thinking about that. We're done here." Eventually, if you let it, that darker path will get covered up with leaves. The leaves will disintegrate over the winter, and by spring there will be new dirt covering it. The path is still there but it's shallow and small and you don't have to fall into walking it.

In the meantime, if you build more positive paths they will become easier and easier to find. One of the biggest realizations that I had is that happiness isn't something that happens to you. It's a choice. There are certain things that I know I need to do to be happy, and I make the choice to do those things— first because I deserve that, second because I have things that I want to do in my life, and third because my family and the people who love me deserve that.

In order to be happy my boyfriend and I run two or three miles a day. I don't eat junk food or sugar except on Sundays when we run to Union Square Donuts and we eat, like, five donuts. Mental health and physical health are so entangled. I just know, if I want to have a good day tomorrow I need to run today, I need to not eat junk food today, and I need to go to bed on time. I just know that those are the preconditions. If your method is mental health it's got some preconditions. You can't expect that method to run properly when you're not satisfying its conditions.

If you are pouring all of your self-worth into preparing for that exam because that is the only thing you've been doing, then of course if you do worse than you'd hoped it's going to suck. But it sucks a lot less when you have other things in your life that you're living for. Calling my family and going on walks—that's actually very nice. When I have a particularly bad day, sometimes my boyfriend will meet me on campus and we'll just go on a walk.

I think it's important to use something other than career or classes to mark the passage of time. For me, it's pages read, distance traveled on foot, and watching my little brother grow up. I'm building myself up as a better writer and thinker by reading and by exploring the world around me. I am actively working on my vocabulary, and I keep a little log of new words. Sometimes I go through them, and it makes me very happy. In particular, I learned the word "scintillating," and I love that word. It's mine now. I know that I'm building something, something that is my own and that is just for me. I'm building my vocabulary, and I'm building my mind, and I'm building myself as a person.

Lydia Krasilnikova graduated in 2016 with her SB *and* MEng *degrees, and is currently working at the Broad Institute.*

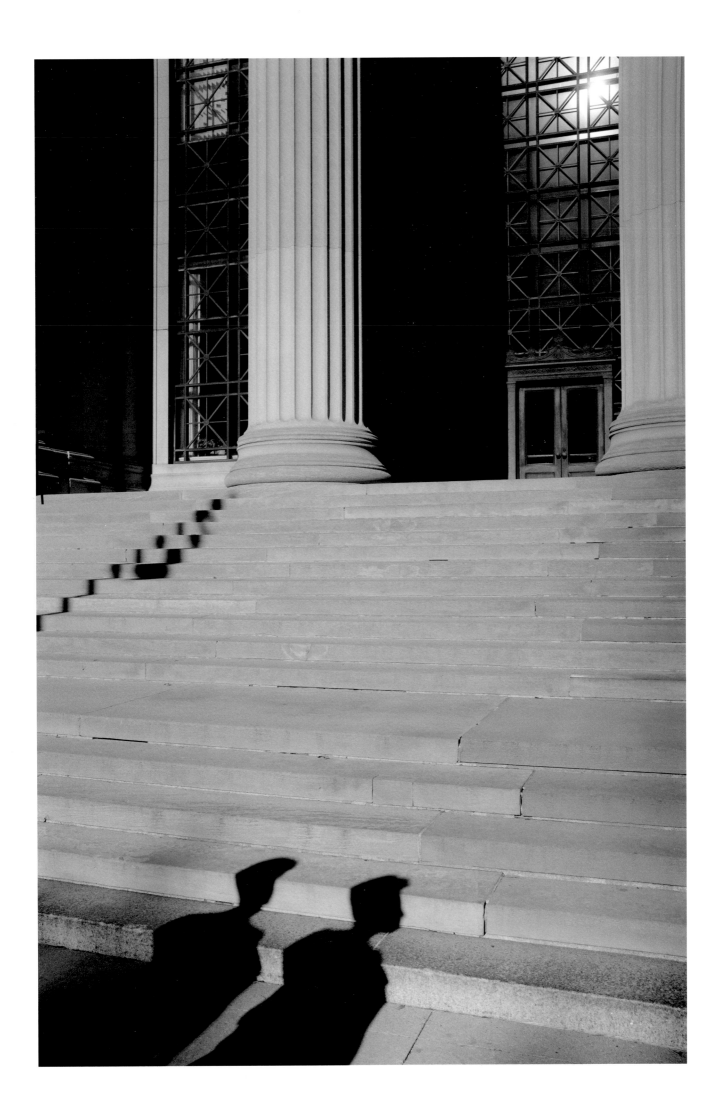

HALEY COPE

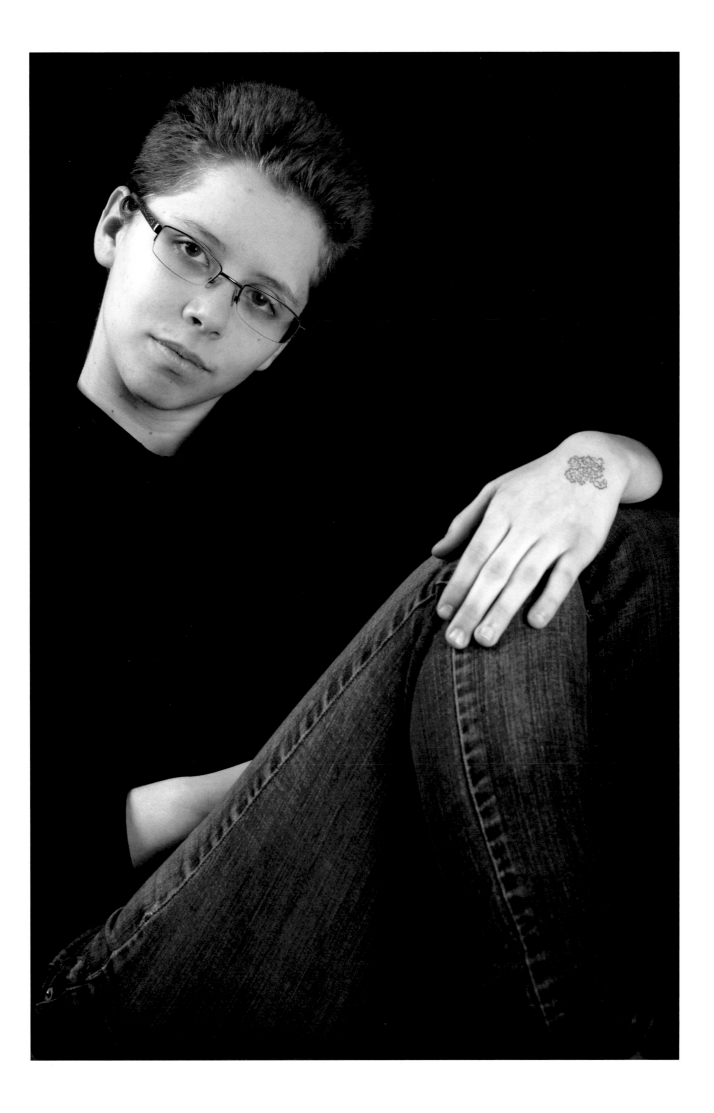

My parents were high school sweethearts. They got married after college, had me and then my two sisters. My father was the primary breadwinner. He worked at a factory making adhesives, and my mom stayed home. When my youngest sister went to kindergarten, my mom wanted to go back to work.

My father viewed working as selfish, and my mom gave in. Things were peaceful for a few years, until she took a full-time teaching job. They argued a lot, and my father eventually escalated to physical violence. So we found a place to rent and moved out one day while my father was at work.

He didn't contact us for months. Eventually it was worked out that we would see him once a week. After one visit, he dropped us off and said, "I'll pick you up on Wednesday." He never showed up, and it's been five years since I've spoken to him.

The second boy I dated was the first person I ever loved (and I still love him dearly). When we broke up in my sophomore year, everything felt like it was crashing down. Our friends chose him over me, and I felt alone and ostracized. My social group fall apart, and my family fell apart, too. My father was once diagnosed with bipolar disorder, so I'm predisposed to depression. For the first time, I started feeling suicidal.

I began writing down my life story and trying to understand what had gone wrong. My intent was to write this story and then commit suicide. But I hadn't finished the story when the time I had planned came. The feeling of not having finished something is often what has kept me going.

I went from actively suicidal to passively suicidal—wanting to die but not wanting to take my life. I started dating a guy who was an MIT student at the time. He was our town's star student, and I really looked up to him. He cared for me a lot and, besides my mother, is the main reason I'm at MIT now. He got me into programming and helped me study for my SATS and APS.

My junior year of high school, I took 6.00x (an online programming course), and I got 92% in it. I did really well in the science competition. That year was my most successful and my most happy. I funneled all my anger and sadness into my work. Hiding in my work is often an effective coping mechanism.

Over the summer, I went to science camp at Carnegie Mellon, and I started feeling sad again. It was a good camp but had a really high-key environment, a lot like MIT. We got our AP scores back, and I had gotten a four in computer science. This other kid was like, "How could you do that? It was so easy." That was when I started comparing myself to others. I'm like, "Wow, I am not as good as anyone ever." I was just sad by the end of it, and I got super burnt out.

My senior fall was OK; I spent my free time writing my essays and taking an online class. But by my senior spring, I was in a waiting game. My future wasn't in my control, and that was when I started getting into the low point where I am now, where I'm passively sad a great deal of the time.

I got into MIT, and I came to campus preview weekend. People were like, "I'm so into these things, and I do this cool thing, and I do this other cool thing." I was just, like, whatever. I don't do any of these things. I've just been focusing on academics. So it became a question of: What do I do? How do I measure my value as a person? I don't really know.

I got pretty depressed again and started self-harming. It was very effective. When I was very sad, bawling my eyes out, it would make me feel instantly calm. I don't do it anymore, fortunately, and the marks have faded. I learned about other techniques that work almost as well. I draw on myself sometimes, because it's a physical sensation that brings me into sharp focus.

I graduated, gave a silly speech, and was finally finished. I started my freshman year here at MIT. I took classes that were too hard: differential equations, multi-variable calculus, a graduate computability class, and physics. I started drinking a lot, and I ended up failing all of my classes that fall.

The next January, I taught high school in Israel, in an MIT program. I really loved the kids, and it gave me a nice context switch. I was around people with different cultural values. When I came back, I got more involved with the Jewish community at MIT. My first exposure to Judaism was through some postdocs I worked for: I heard their stories, and how it shaped them, and I celebrated Rosh Hashanah with them. I'm actually in the process of converting now. It's really nice.

That spring, I took more appropriate classes. I ended up pulling an A in the physics class I'd failed in the fall. I joined a sorority. I had my social life and my academic life pretty locked down, but my mental health was a train wreck. I had started going to therapy after a freshman in my dorm committed suicide. I didn't know him personally, but I saw the impact on the community, on people he didn't even know. We were terribly sad and sat in our dorm lounge just

crying and holding each other. I'm like, wow, this is really shitty. I don't want to be a contributing factor to that kind of sadness.

I started taking Celexa. It made me sleep more and withdraw socially, and I had a lot of suicidal ideation. I kept telling my therapist, "Hey, this isn't working." He was like, "Try another week." One week, I said, "Listen, I can't do this. I absolutely cannot do this anymore," and he was like, "See me on Friday."

Over the next two days, I really wanted to commit suicide. I said this to the therapist and he said, "I'm going to have to go talk to someone about this." As soon as he said that and left the room, I'm like, "Fuck, I'm going to get transported." Sure enough, when he comes back, he's like, "I'm sorry. We're going to have to transport you now."

I waited in the MGH lobby for seven or eight hours before I got moved to McLean. When I got there, I was wearing my boyfriend's hoodie, and they took it from me because of the string. I just wanted a nice soft hoodie. I was used to sleeping with him every night, and suddenly I couldn't do that, and suddenly I was alone, and I was crying. One of the nurses said, "Just do what they ask you to, and you'll get out sooner." That was the least encouraging thing I had heard in a long time.

They put me in the short-term unit, so I could still contact people. I had friends visiting me every single day I was there, and I appreciated that so much. Overall, it was a trippy experience. Suddenly you're in a hospital and someone is coming to check in on you every 15 minutes to make sure you're not hurting yourself, even when you're sleeping.

On my first day in McLean, I made a friend. It turns out we were in two classes at MIT together, but didn't know because both of us were really sad and depressed and never went to class. He and I are still very close, and we talk every single day. It's really funny. Whenever people ask us how we met, there's always this

looking at each other: "Are we going to tell them?" We usually do. Neither of us is ashamed.

It was a very stressful week because I didn't hear a lot from MIT. I didn't know if I was going to get kicked out. Eventually one of the MIT psychiatrists came to see me, but I had been in there for four or five days at that point. Anyway, I got out of there, finished up my finals. Went to Atlanta for the summer. I came back to school in the fall and did well in my classes.

This spring has been kind of rough. My classes haven't been going super well, I've been withdrawing from my friends, and I haven't been able to find a regular therapist. I wish MIT Mental Health could help with that.

It's funny, the guy I met in McLean also converted during our time at MIT. He converted to Catholicism. Judaism is very focused on what you do and how you live. The focus on life is what made an opening to me. The idea that I could be learning and studying, and acting in a way that makes me feel like a better person is really appealing. I also really love Shabbat. I don't yet fully keep it; it's something I'm working toward. The idea of setting aside time to reflect and be grateful is really important to me. People at MIT are inclined to think, "Well, religion says these things, like the world is 6,000 years old. That's obviously stupid." They focus less on the aspects that enrich people's lives. There are a lot of assumptions about what it means to practice religion, and I don't think they're accurate or reflect what people experience, or why people are religious.

As far as other life plots go, I've recently decided to switch majors to Women and Gender Studies. I'd like to graduate from MIT, get some form of a job, probably in software development or information security, then just be calm. Having a work-life balance, that's the biggest goal I will have for myself. Settle down with my partner, and eventually have a family. The American Dream, I guess.

Haley Cope is a member of the Class of 2018.

ANITA HORN

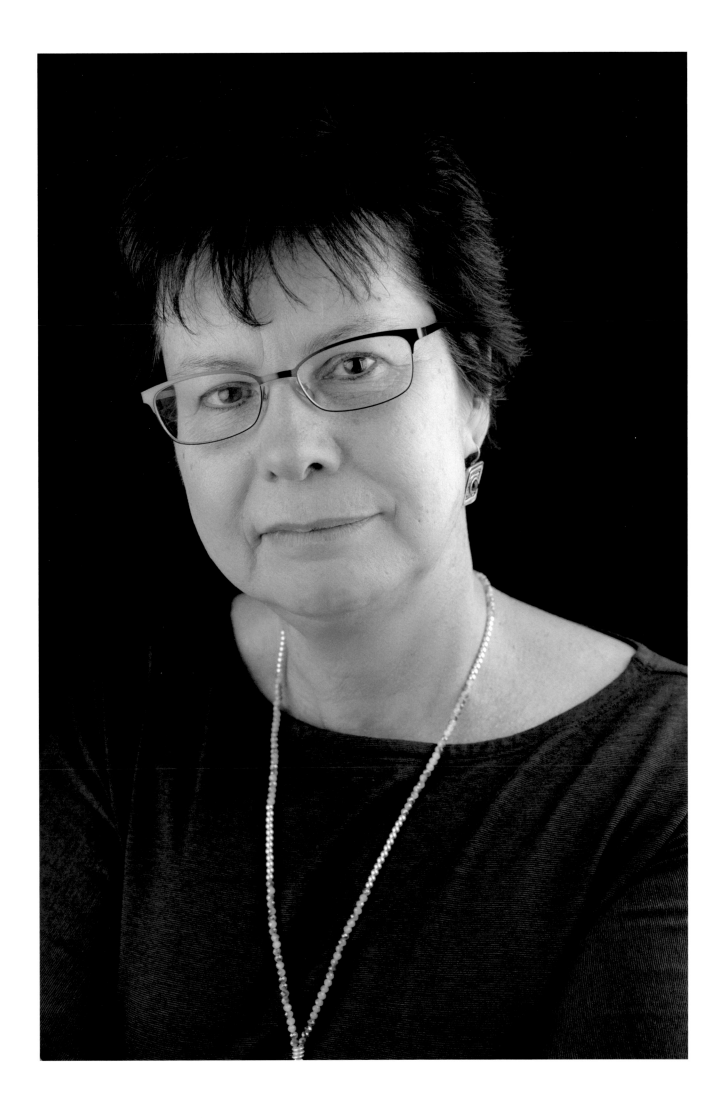

In many ways, I had an idyllic upbringing. I was the seventh of eight children. My family was very close, and my parents were always there for me. I had a babysitter exactly once growing up. But my family thought that people wouldn't tell you if you were doing something wrong, so it was their job to do that. I was kind of weak, and a very shy child. My siblings were 13 to 23 years older than me, so it was like dealing with seven parents at once. I don't think they knew the impact that their words had on me.

I was fine until I was a teenager. That was when I first started feeling like I wasn't good enough, wasn't measuring up. I went to college, and moved to Denver. I struggled with feeling unstable. I needed other people, I needed their approval, I needed to be married or in a relationship.

Then I moved to Boston, and the shit really hit the fan. It was horrible. I was 28. I talk about it as my great depression, my emotional stock-market crash. I didn't know anybody, and I found it nearly impossible to reach out to people. I struggled for a year and a half, and I was suicidal for a large part of that time. I went to a couple of psychiatrists, and it was just a big mess. When I described a session with one of my friends a few years later, they said, "Did he give you a gun on the way out?" It was that bad.

I was in a constant state of almost crying, or struggling to hold back tears. I would go into the bathroom at work and cry, cry, cry. People at work—I couldn't believe they didn't notice. Someone would ask me, "How was your weekend?," and I'd say "Oh, not that great," and then they would go off on their own thing. My inner experience was so far away from what people were expecting that I couldn't even begin to broach the subject of the pain that I was in.

Things got really bad on the weekends. I felt like I had a cloud around my head, and I would walk through my neighborhood and it was like nobody saw me. I felt completely separate from the world. It was like looking through a tunnel, and people seemed so far away. At one point I went to the emergency room on a Friday, and the resident who saw me was somewhat hostile, as if saying, "What are you coming to me with this stupid thing for?" She gave me Ativan, which was inappropriate, but it got me through. I hoarded those pills. I would take one or two every weekend when things got bad (which was every weekend).

I was not the kind of person who could chat with people. At stores or restaurants I would pay and leave. I kept my eyes down, so people would be even less friendly than they might be. I would spend the whole weekend by myself. I tried to have a couple of rituals: lunch at this place or breakfast at that place, just so I could get out. It was really, really tough.

I met a couple of people at work who were really friendly and lived near me. They started calling me. These friends were really wonderful and sort of brought me out. Then a friend in Colorado that I'd talk to once in a while told me about these Insight Seminars. I was having back issues and went to an acupuncturist the next day, and, lo and behold, he starts talking about Insight Seminars. Then, I came back to my apartment, and in front of my house was a car with an Insight Seminars emblem on it. I was like, OK, I guess I'm supposed to do this.

So I went to Insight Seminars, and it changed my life. You do these little processes and they seem like nothing. One night, I was lying there, and one of the exercises that day had been about guilt and resentment. I had been processing this resentment that I had for this boyfriend who didn't share my feelings. I somehow just got to the point of forgiving him. I flew out of bed and ran over to my roommate and said "Oh my God, you'll never guess what I just realized." I was ecstatic that I could just change the story on my own, and change my feelings.

Up till that point, I felt there was nothing I could do about my emotions. They were dependent on somebody apologizing to me, somebody saying they love me. I just thought, you are this way, that's the way you are forevermore, there's nothing you can do about it. It was just a miracle to me to discover that that's not true. I can actually decide to feel different. I didn't need to be shy. I could be shy, but I could also practice not being shy. That was a concept that I was completely unaware of.

Everything I learned there in that one seminar has changed every moment of my life since. It didn't resolve my depression, but it gave me all kinds of tools to help make it manageable. I would still go into funks, but they would be for a few days or a week long instead of months long.

I started practicing little things like going to a bar by myself, sitting at the bar and saying hello to the bartender. Or sitting on the T and asking the guy next to me what time it is. I had been afraid of the dark, but I realized I wasn't any more. I can shut off a light and walk into my bedroom and not expect someone to jump out at me.

I got my job at MIT, and I went to a psychiatrist as a preemptive measure because the holidays were always really hard. He thought I had seasonal affective disorder and suggested I try this medication called Celexa. Within a week, I was like, "Oh my gosh, this is what normal people feel like." That medication gave me winter back. I take it now from September through April.

What you see in other people isn't all there is. You might be thinking everybody else around you has it together, but they really don't. You find out about that by being honest and vulnerable yourself. I used to think that the goal was to be perfect and that everyone expected me to be perfect. I don't feel that way anymore. I can do things that are wrong. I can make mistakes and be sorry about them and apologize for them. It's absolutely not about being perfect. That's not the goal and it's not human.

Anita Horn is a Service Quality Specialist in the Technology Services department of the Sloan School.

JUSTIN BULLOCK

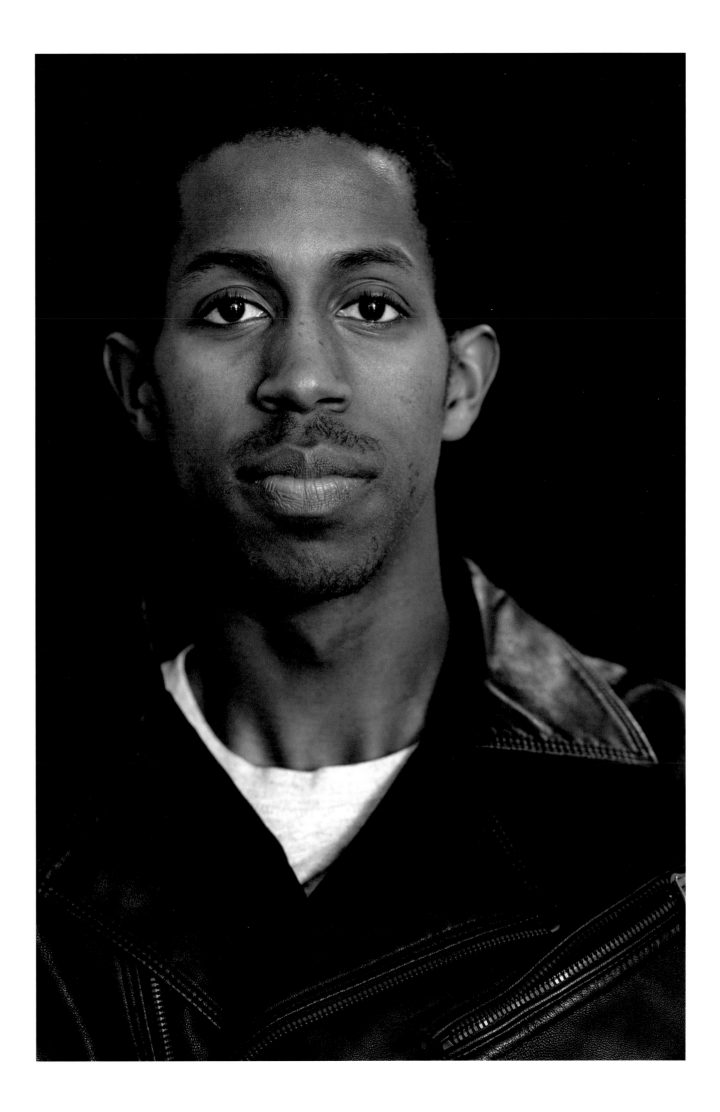

I grew up in Detroit. My father abused my mom, so my parents split up when I was 7 or 8. After that, he had a new girlfriend, and apparently she made him upset, and he poured gasoline all over her furniture and lit it on fire. He was a fireman at the time, so it was pretty bad. He also had a gun, and he fired it off in the building. When they were in court, the girlfriend was going to drop the charges, but her sister really hated my dad. She spat in my dad's face, and he punched her, right there in the courtroom. So he went to jail.

Sometimes he wrote me letters when he was in jail, but we didn't talk very much. Now that I'm a bit older, I feel a lot angrier toward my father than I did when I was younger. I've seen him probably two or three times since then. I see my mother all the time. We have had some rocky times, but we have a good relationship. She still lives in Detroit. My two older sisters live near me out in San Francisco.

After my parents split up, my mom remarried. My stepfather wasn't employed, and he was an alcoholic. I'm not a physical person; I don't fight. But my stepdad and I got into multiple altercations. One day, he got into an argument with my sister; it became physical, and soon I got involved. He pulled a gun on us. I'm pretty sure he wasn't going to shoot us. He was just kind of flexing, trying to be intimidating. That was the day of my prom. It's a memorable day for my family that we sometimes laugh about. We all have a dark sense of humor, and we joke about a lot of things, because a lot of not-so-good things have happened to us.

My mom's really awesome. From a really young age, she always pushed me and my sisters academically and kept us involved in all of our activities. I started playing soccer but eventually took up running. School was always something I enjoyed. I did a few really cool summer programs, including one at Princeton in my junior year that helped me a lot with college prep.

I came out when I was 17, in my senior year of high school. There was a lot of conflict between me and my mother around that. She had a younger brother who was gay and who died from AIDS in the '90s. When I was growing up, she said a lot of things like, "A man's supposed to be with a woman." My grandma had gotten me a car for my seventeenth birthday, a '97 Chevy Cavalier. After finding out that I was gay (and dating someone from my high school track team), my mom was like, "Give me your car keys, cell phone, computer. If I don't believe in something, I'm not going to fund it." She meant funding my "gayness." Since then, things have gradually improved between us.

The summer before I came to MIT, I did Interphase, a summer program for underrepresented students, which helped the transition from high school to undergrad. It helped me meet people, start to build a community, and take the big academic step up from my high school to here.

Freshman year was good. I started running track. I was very focused, and I was doing well in my classes. I joined a fraternity in the spring. There was this one guy, John (let's call him that), who I became really good friends with. We were hanging out all the time and both planning to do Course 10, Chemical Engineering. We just hit it off. We were the leaders in our pledge class.

The summer after freshman year, John and I were hanging out, because he was also at MIT for the summer. He was straight, to my knowledge. One day, I spent the night over at his place, because I had finished in lab pretty late and didn't want to walk across the river back to my fraternity house. We were sleeping head-to-toe in this twin bed, and at one point, he said something like, "We should sleep the same way" because then there's more space. Pretty soon after, he put his arm over me. I remember immediately waking up, like, "OK, this is very weird, because I have clearly expressed where I stand on this sexuality spectrum." That happened and there was no conversation about it. It happened again another day, and eventually I said to him, "I think I like you," and he said, "I like you too." So we started kind of dating.

Basically, I felt pretty strongly that we should tell the fraternity, to just get it out there. It went really badly. They were very unhappy. One guy was John's "big brother," and he thought John was the greatest thing in the entire world. He told some other brothers that I seduced him. That was really hurtful. They were going to make a rule that no two brothers can ever date in the fraternity. On some level, I can understand they didn't want it to turn bad and then have all these toxic things happen, but the toxic things were happening because the other brothers were being toxic. John and I started getting into arguments because he would often defend the fraternity. For me, that was really frustrating. I was the outspoken one and was taking all the heat from the fraternity.

I decided to move back onto campus. John started staying with me. It was a single, but it was a very, very small room. Things between us became very tense, and we broke up. One day I came back to my room

and all his stuff was gone. We were still in all the same classes, so I saw him all the time.

I stopped doing so well in my classes. At the beginning I was getting all As and then all As and one B, then more Bs and Cs. At some point, I went into mental health and started seeing one of the therapists. Pretty quickly he said, "Maybe you should think about taking meds." But everyone in my family was like, "No, Justin. You don't want to mess with your head. You're going to be stuck on them." My family didn't really understand where I was and what was going on with me internally.

Things got worse and worse. While the depression was starting to kick in, I was running really, really well. When I'm emotionally stable, I do really well in school and athletics. As I become emotionally unstable, for a short period of time, I do even better; it's like me compensating for not feeling good by focusing on other things. In my freshman year I was the slowest person on my team. By the time I graduated, I had one school record, one freshman record and two, top-eight finishes at nationals on the MIT distance medley relay team.

Fall semester of junior year was when my downhill slide turned into a free fall. I stopped going to class. There was still this John obsession. I could not be in the same room with him. I wanted to talk to him, but I couldn't. My thoughts would cycle over and over, and I could not function.

Soon I was sleeping thirteen to sixteen hours a day. When I think back to that time, the most painful thought is that I could see that my friends were trying so hard to help me. They would come into my room, and I would just look at the computer and not look at them and not talk to them. I just couldn't, or wouldn't. They would leave, and I would want them to stay. But why would they stay when I wasn't interacting with them at all?

I gradually became suicidal. Initially it was very passive—I-don't-really-want-to-be-here kind of thoughts. I was thinking of ways to hurt myself. I knew I wanted to go to med school, but the depression was saying, "Justin, you're not going to go to med school. You're just being a pitiful sack of nothing. You're going to fail all these classes. How are you going to go to med school when you can't do anything?"

One day I decided I had to leave MIT. I couldn't be near John. I couldn't go home, but I couldn't be here either. John and I were in the same advising group. Six of us were going to have a dinner with our advisor. I told my psychiatrist, "I'm really stressed out about this dinner, but I have to go." He said, "Why do you have to go?" I said that when I'm in the real world and there's something like this, I would have to go. He said, "No, in the real world, you could also just not go to this dinner." I met with my advisor to tell her this, and she asked me what was going on. I remember breaking down and crying in her office.

I don't remember what she said, but I do remember she was really comforting and that made me feel very cared for. Honestly, MIT has a great mental health system. Obviously, a lot of it is because there have been so many suicides at MIT. The people who go to MIT are the kind of people who don't ask for help, are perfectionists, and keep going even when they feel terrible. Mental illness doesn't discriminate, though. It can break even the strongest person.

The last person to tell I was withdrawing was my track coach. Even to this day in med school, I am MIT Track. I live, breathe, and die MIT Cross Country and Track and Field. I was a captain my junior year for the track team. So how was I just going to leave? Coach Taylor said, "Are you going to tell me why?" I said, "It's complicated." He said, "I've got time."

Coach Taylor is a very manly man: he exudes masculinity. He's from South Carolina. He and I had become really close. Even in my freshman year when I wasn't very good, I was meeting with him and talking about sports psychology, and competitiveness being more important than your actual fitness. And now I was thinking: I can't tell him about this guy that I'm obsessed with and that the obsession is controlling my life.

I told him what was happening, and he asked me if I was taking meds. I said my family was against it. Basically, he said two things. The first was, "You can't run away from your problems. Just leaving won't fix anything." The second was, "If the doctors say you should take medication, then you should take medication." He was someone who I viewed (and still do view) as a father figure, because that's something I didn't have very much while growing up. I respected his opinion, and I followed his advice.

The first thing the meds did was muffle the bad thoughts, turning the volume down so I could start to do something. I had been sleeping during the day and not at night, and I started to sleep appropriately. It was a very slow process, over two months or so, and things started to clear a little bit. My problems didn't go away, but I could begin to deal with them.

Professors knew what was going on. In one class, I got a C-. That means "you deserved a D, but we're nice, so we're going to give you a C." They were letting me turn assignments in late. That semester, my GPA dropped by 0.4. This is junior year, so that's a very large drop. And I was running poorly, too.

John had his own mental health problems. He volunteered in the Boston Marathon and was pretty close to the finish line when the bombs went off, and he had a lot of PTSD and anxiety from that. I stopped seeing him around.

Later that season, my team had a cross-country meet. It was the best race I had run in a long time. My coach said, "Whatever you are doing, do not change anything." I said to my psychiatrist, "If this med is making me run faster, I don't want to take it." But he told me, "It's not the medication doing anything. It's the fact that you're sleeping and just mentally more able to give." Later in December I set the MIT record for the 3,000 meter race indoors, which still stands. It's probably going to get broken this year.

Things started turning around for me. For so long, everything was very gray. In senior year, stuff started being in color again. During freshman orientation that year, six or seven upperclassmen shared stories of different struggles they had had at MIT. It was really powerful—not just to speak about it but also to look at everything as a whole.

I applied to medical school. I acknowledged the glaring spot in my academic record, and I decided to be open about it in my essay. I got a lot of pushback from my friends and family. But I thought: if doctors don't want people who are sick, then that's kind of stupid.

I didn't end up having to go to a psych hospital when I was at MIT, but I did it twice when I was at UCSF. I stopped taken my meds, and my depression came back, and it came back much worse. I never drank in college (except on my twenty-first birthday), but I started binge drinking, and was this nonfunctional person on the weekend and then functional during the week. I was still doing really well in med school. MIT is so hard, which makes anything else seem easier.

I attempted suicide. I was in the ICU for three days, and then in the regular hospital for a few days. Then, I went to a psychiatric hospital for eight days. After that, I tried to go back to school too quickly. That's how I ended up back a second time for five days.

UCSF has this day once a year called Mental Illness among Us. Four or five members of the class share their story about mental illness. It was definitely a powerful bonding moment for our class. It's saying there is mental illness among us and you wouldn't know. I shared part of my story with my class.

I try to be really proactive about mental health. When I got very depressed, I was going to therapy three times a week. I exercise so much. But there's some point where I can't do it just with conventional things, and I need medication. That's hard to accept. I told my psychiatrist recently that I don't think I could make it through another depression. Each time has been so much worse. It's honestly one of the most terrifying things for me. When I talk about it in therapy, the thought alone can make me cry.

People have family members who say, "Don't take meds." Our whole society is set up to say, "Don't take meds. You don't want to be a crazy person. You can do things without meds. You should get off them as soon as you can." I was one of these people who said, "Oh, I was on antidepressants, and now I'm off. I didn't have to stay on them." That's not always a good thing. My diagnosis is actually bipolar disorder, not depression. My father's bipolar. The medication I'm now on, Lamictal, is the one that the first psychiatrist I ever saw wanted to put me on, which is pretty interesting.

It's kind of crazy that I was able to end up at a place like UCSF. I was lucky in that I got into a few really good medical schools. Being from MIT is a huge boost anywhere, and I think that UCSF appreciates the humanity of its applicants and me being open about my struggles.

I am in the best place I have been in for an exceptionally long time. It's not because I don't have problems going on, but that I'm doing a relatively good job of not letting them control my life, and not feeling like I have to be off meds. Honestly, from what happened this most recent time, I can't imagine there ever being a point where I would be willing to risk it again.

Justin Bullock, Class of 2014, is a medical student at the University of California, San Francisco.

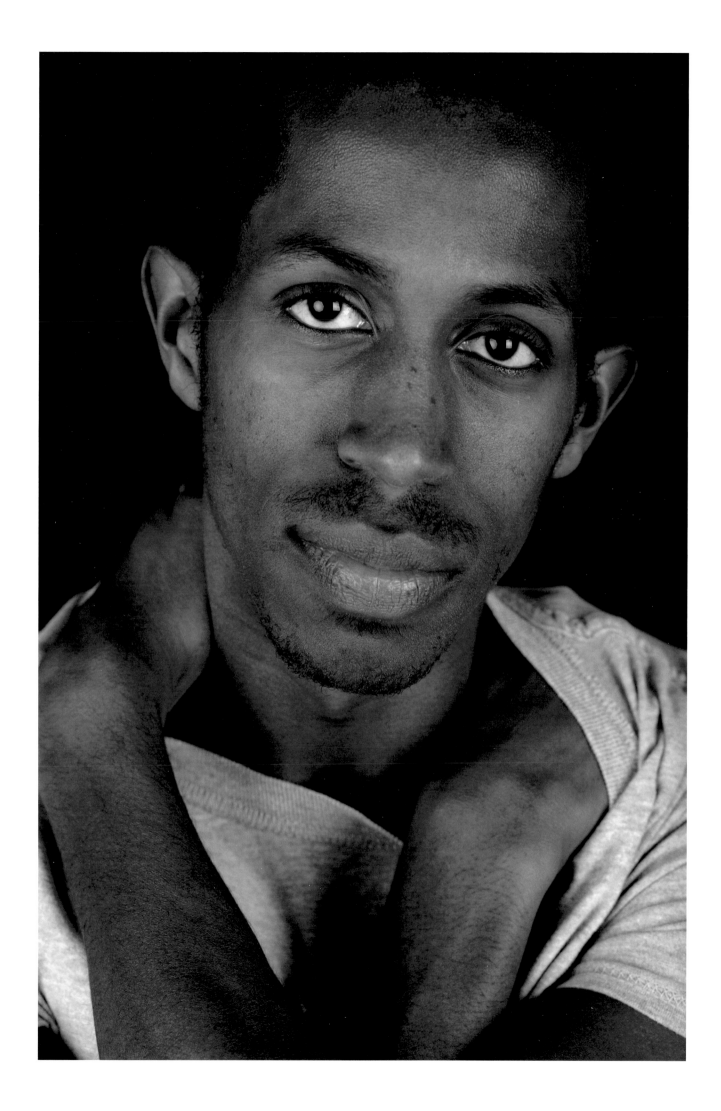

BARBARA JOHNSON

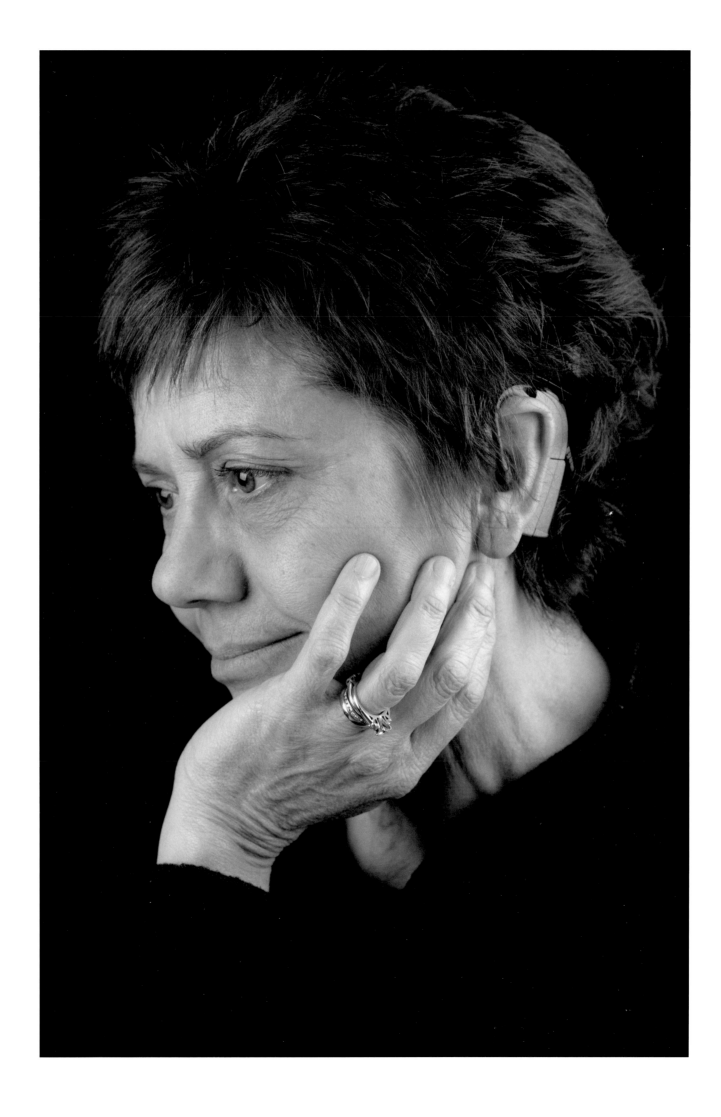

My hearing loss is genetic, and it runs in my family. When I was in grade school, they would bring groups of students in to the nurse's office for an annual test. We would put on these big rubber headphones, and we were supposed to raise our hand when we heard a sound. I would watch the other children and when they raised their hands, I would raise mine.

I didn't know I had hearing loss. It just didn't enter my mind what the purpose of the exercise was. Finally, when I was about ten years old, I stopped raising my hand. That was when I got my official diagnosis for hearing loss.

I don't remember a single conversation with my parents about my hearing loss. Not one. I'm from a very big family; I'm the eighth of nine children. My father ran his own business and was working nonstop to support all of us. My mom figured if I wasn't bleeding and I wasn't in jail, things were good. And I was doing well in school.

My father passed away some years ago. My mother is still alive, but she's in a nursing home and has dementia. I see her every week. Like a lot of older people, her voice has gotten a little softer. I found myself saying "Oh, I'm sorry, Mom. I'm sorry that I don't hear better, that I keep asking you to repeat." She said to me, "Well, I feel bad." Maybe that's why she didn't address it—because she felt responsible. When I'm ready to start asking the questions, there is no longer access to the information. It's kind of bittersweet.

I have a typical sensorineural hearing loss. You start losing the high frequencies first—for example, the sound of crickets on a summer evening. I remember hearing them when I was very young, and then they just dropped off. About every 10 years it would fall back a little more, a little more. I would just make do. I was strategic about how I would communicate. I relied a lot, and still rely a lot, on lip reading. I would position myself so I could see the speaker. I'm a very good guesser, too, based on context. That's why accents can throw me, because my guessing is based on a Boston accent.

After college, I would occasionally go to an audiologist for a check-up. Each time they would say, "Yes, you definitely have serious hearing loss." But the loss was so profound that a hearing aid wouldn't have assisted me. A few years ago, my hearing had declined to the point where I needed help, so I went to get evaluated again. I remember asking the doctor, "Am I deaf?" She said, "Yes, with a capital D"—meaning that I was profoundly deaf. I wasn't shocked or dismayed.

I wasn't upset. I was just more, like, "Well, why didn't I know that?" They told me, "You're a candidate for a cochlear implant in either ear. You can pick an ear."

They had different groups where you could find out more about the devices and meet people who had them. At these meetings, they had live captioning. I was shocked. How come I didn't know about this? That launched me into this whole advocacy role because I realized that if I didn't know, there were plenty of other people out there that didn't know either.

It is actually not an elaborate surgery at this point. They make a little incision behind your ear. They pull the skin back and then they drill a hole in your temporal bone to get access to the cochlea. Then they insert the implant under the skin, thread in an electrode and stitch you up. You wait for about four weeks to heal, then you go in and get the external device. The audiologist will do a "mapping" and will set a certain program and introduce you to sound.

You have no idea how loud the world is, and it is really loud when it first gets turned on. In addition, you have to start understanding what these sounds are. Things I hadn't heard before, like everything that beeps. My microwave beeping, my dishwasher beeping, all these things that I didn't know made sounds. Riding in the car, the road noise just felt like it was torture. After a while you start to get used to it. I was walking the dog with my husband, and I heard a sound. I asked him if it was a car alarm, and he said, "No, that was crickets."

The implant doesn't give you normal hearing. I think I was hoping I would use all the skills that I had acquired through the many years of my hearing loss, and then I would add onto them some new skills by virtue of the implant. That's not how it works. It's like wiping the board clean and starting over. That depressed me to some degree, so I just tried to keep going.

I felt a bit embarrassed because I felt like people that I worked with and family members were anticipating this big change. It was a big change, but I think that they were all also a little disappointed that I still had hearing difficulties although nobody said anything to me. It's not that anyone told me that I would have perfect hearing, but I just didn't really understand that I would still be a person with hearing loss. I just don't want to have hearing loss. I just don't.

There is a lack of understanding about hearing loss. It's just a kind of a lousy group to belong to.

When I ask people at an event to use a microphone, I get resistance. I'll say "Why don't we just have open captioning?" and sometimes I'll get, "Well, that will be distracting for everyone." You will ask for something to assist you, like remembering to get your attention before they start to speak, things like that. People will forget and you have to ask again. I don't take it personally, but part of it tells you, well, you're not important. It makes you feel a little less valued.

Oftentimes, people don't think. If you don't hear them, they'll say "Oh, it wasn't important." That's the worst thing. I know they don't realize it, but it's a message that says you're not important enough for me to repeat that.

People ask me if I'm deaf. It's hard to know what to tell people. I'm not fully able to do everything a normal hearing person can do, but I'm not really accepted in the Deaf community, since I don't have fluency in ASL. I am deaf, and I would like to be more Deaf—meaning, belonging to that group.

I've said to people things like, "Well, you know, I've come out as a deaf person." I was pretending I was a normal hearing person, but I really wasn't. When they told me I was deaf, it was like telling me I was from another country, and I didn't know it.

I started exploring what that means. What's that country like? What is the culture?

Now I'm learning ASL. It's very attractive to think that my effort can actually pay off and can introduce me to people who I can easily communicate with, who don't get annoyed at me because I don't hear well.

I find a lot of support and power in connecting with other people who have similar challenges. The hard part is finding those people. I do talks on advocacy and education about communication access. I just keep hoping that I'm emboldening more people because if enough people talk about what's a challenge, then it becomes not a big deal.

We want to make a community that's compassionate and inclusive, but how do you do that? If more of us start talking about what's going on with ourselves, with our challenges, then, in fact, we are doing something tangible, aren't we?

Everybody has something going on. Everybody. No one is immune. I tell people, if someone tells you that they have nothing going on then they're lying. Really. Everyone has challenges, right?

Barbara Johnson is a support engineer in Information Systems and Technology.

KAREN HAO

I think my depression started with a not very healthy relationship, but it took me a very long time to realize that. It was the beginning of my sophomore year; I had declared civil engineering, and I suddenly realized that it was far from what I wanted to do. I started wondering whether I had even chosen the right school. My parents started talking about transferring—and that thought in itself was kind of horrifying. Did I really screw up my college decision?

I had already started sensing something changing emotionally at the end of my freshman year. I tried to figure out the problem so that I could find a solution. The problem that I identified was that I didn't have a strong community. So I thought, OK, I sang throughout high school—this is something that I love. I'll try out for a cappella. Not only will this be a great use of my time and energy but it will also be this great community. I was super excited. When I didn't get in, I felt like I'd tried and still failed, and now all I had were dead ends.

The scariest part of my depression was looking at myself in the mirror and no longer recognizing who I was. I felt I had adopted other people's priorities and values. I didn't really know what I cared about any more, what I valued, who at my core I wanted to be. I had always considered myself a resilient person, but that was gone. I had always prided myself in my ability to articulate emotions, but that was gone, too. All these pieces of my identity had slipped through my fingers without my noticing, and I was suddenly confronted with the stark realization that I hated the person I'd become. But I didn't even know how I'd come to be this person.

That year was the worst experience of my life, and I wouldn't wish that on anybody else. But I also wouldn't want to rewind and not have the experience. I think it developed my depth and complexity as a person, in terms of the breadth of emotions I can experience. I feel like I'm a much more empathetic person now.

A lot of little things lead you into and out of depression, so it's really hard to pinpoint any one thing that helped me recover. During moments when I had more motivation I would immediately act on it. Like, there was one day when I felt particularly motivated, and I thought, I need to make my future, self-commit now. So I sent emails to the music department and to different voice teachers to set up voice lessons, because I knew that even if I lost my motivation later on, I would still feel at least some kind of minimal responsibility in meeting the commitment. I would do things like that. I also noticed that I felt most comfortable when I was around other people, so I booked my schedule full of meetings with other people.

It was the hardest when I was alone. There were also times when I was with people but felt very removed, because I felt like I couldn't fully talk to them about what I was experiencing. None of my friends knew. I didn't want to burden them with that information.

The biggest thing that I always advocate for is doing less, so you can sleep more. A lot of people at MIT get caught up in the idea of doing things not because they love it but because they feel like it proves something about them. Like, "If I can juggle this many classes it proves that I'm really smart." I would talk to people I know, and they would say, "Yeah, I hate this. I wish I didn't have to do this." And I'd say, "Well you don't have to do it. You have the choice not to." This tension of wanting to be a super-student all the time—it really runs you down. You end up spending tons of energy on things that you don't necessarily care about, then you cut down on your sleep, and it becomes this huge spiral.

What do I see in the mirror now? I definitely think it's a new Karen. I feel very at peace, not only because I've learned the hard way to really pare down my activities to the ones I genuinely love and care about but also because through my experience with depression I've learned the person that I want to be. So I try every day to be that person. When I look in the mirror now, I think this is the person that I'm striving to be.

Karen Hao is a member of the Class of 2015.

MARY TELLERS

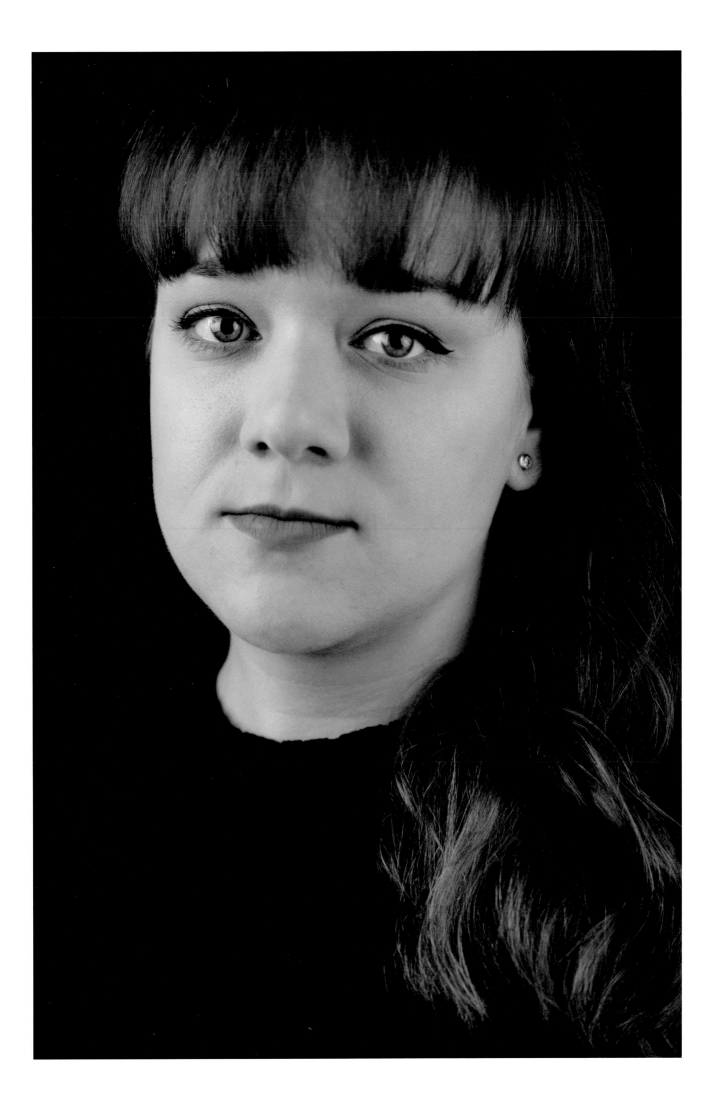

I was always a happy kid. When I became a teenager, my sister ran away from home. She was still going to high school, and I was the go-between. It just crushed my parents. That was the first time I felt depressed. When I was 18 or 19, this darkness came, and I knew it was something I was going to have to live with my whole life, and fight my whole life, and how much that sucked.

In March of my senior year in high school, I got a very bad sore throat. Eventually, my pediatrician just said, "You need to go to the ER, and they can figure out what's wrong with you." The nurse read my temperature, and it was 41 Celsius. She tried to convert it for me, but it was off the chart. My mom is a nurse, and she's the one that noticed that I started going septic because my legs went purple. I was put into the ICU. I had the Sacrament of the Sick, which is like the last rites.

I was delirious and in so much pain that I don't remember most of that time. It turned out I had Lemierre's syndrome, which is a sore throat that turns into a blood clot. It wiped out most of my energy during my senior year. Everybody else was celebrating, and I was just grateful to be alive. Going into college, I had this story to tell. It made me really, really grateful. I still celebrate Life Day, the day I got out of the hospital. It's going on nine years.

My junior year of college, I studied in Toulouse. While I was there, my dorm had a fire early one morning. Half of the building was an inferno. There were some pretty crazy rescues of people jumping off the building. They got us into a cafeteria and told us that someone had died. It was surreal how they said it first in French, and you could hear all of the people who understood gasp. All of the people who didn't were looking around, like, "What just happened?" And then they said it in English. There was something about that gap—that's the feeling I go back to. I always leave a building if there is a fire alarm, and I always send wishes of good will to fire trucks.

After I graduated, I went to work for the Peace Corps in Guinea. One day, I was sitting next to a pool in a beautiful house that the country director owned. Suddenly there were footsteps, and this man appeared, like a tar-dipped skeleton. He ran at me and tackled me to the ground. My only thought was "I'm not going to let this happen without fighting back," so I bit him. It didn't work because biting someone's scalp is really ineffective and all I ended up with was a mouth full of sewage-y hair. It was not good, but part of me is still proud of the fact that I fought back. Later we found out he was being beaten by someone in his family, and he was running away.

A week later I had my first panic attack. Someone dressed all in black had come toward me with both hands forward, which is a very respectful way to shake someone's hand. I couldn't see him well and I flinched. It was so rude of me, and I was beating myself up about it. I came back to my compound and found out that down the road a semi-truck had hit a car and all seven people in the car had died. That was my running route, so for the next seven months I ran past this destroyed vehicle.

I tried to deal with it, to get a handle on the fragility of life, but things kept happening. I got a bad sore throat, and I thought: I'm in a West African country with no health infrastructure, and I'm going to die. I had a complete meltdown. It ended up being some weird infection, and I got better.

From then on I had PTSD. I was having nightmares every night, that there was someone in my room standing over me. In late May, a child was hit by a truck, and my best Guinean friend said I should stay away, but I still think I saw body parts on the road. Two weeks after that happened, it was time to come home because I was crying every day.

I didn't realize I had PTSD. I was working with the Army, and I went to a seminar on a virtual counselor they have for veterans with PTSD, and she was describing the questions it will ask you, like: Do you have nightmares? Do you ever feel like you're re-experiencing bad experiences? I was, like, check, check, check. I got this cold feeling that I was really sick and messed up.

I had started drinking way more than I ever drank before. Once I finally realized what was wrong with me, I said: you've got to stop drinking and you've got to get help. I read up on treatments. I got cognitive behavioral therapy, and antidepressants, which I felt shameful about, even though I knew that medicine is not something to be ashamed about.

I imagined I was at the bottom of this dark pit and trying to scrabble my way up the sides. When I got on medicine, it was like someone said, "Here's a step stool." I was still in the pit, but I was five feet closer to the top. I swallowed up any bit of pride that I had had, and took every bit of help I could get. Gradually I started getting better.

Anyway, when I came to MIT, I felt pretty good. I practiced changing my thought processes. Mostly

I have this fear of cars. I just give myself five to ten seconds to make it through that scary period. If you're still good after that, then you're alive and it's OK. If they swerve and hit you, you're dead anyway, so what does it matter?

I think of PTSD as an injury rather than a mental illness. It's like my tennis elbow. Over the course of multiple traumatic events, I injured it. Now when I think it's going to get injured again, I protect it.

You have to believe that there's a light at the end of the tunnel. I'm not sure there is for everybody. PTSD isn't something that people always come out of, but I believed I could, and that may be why I'm doing so well right now. I might not be great forever, but if I am ever in that dark pit again, I have the tools to climb out.

Mary Tellers is a graduate student in Mechanical Engineering.

MICHAEL MCCLELLAN

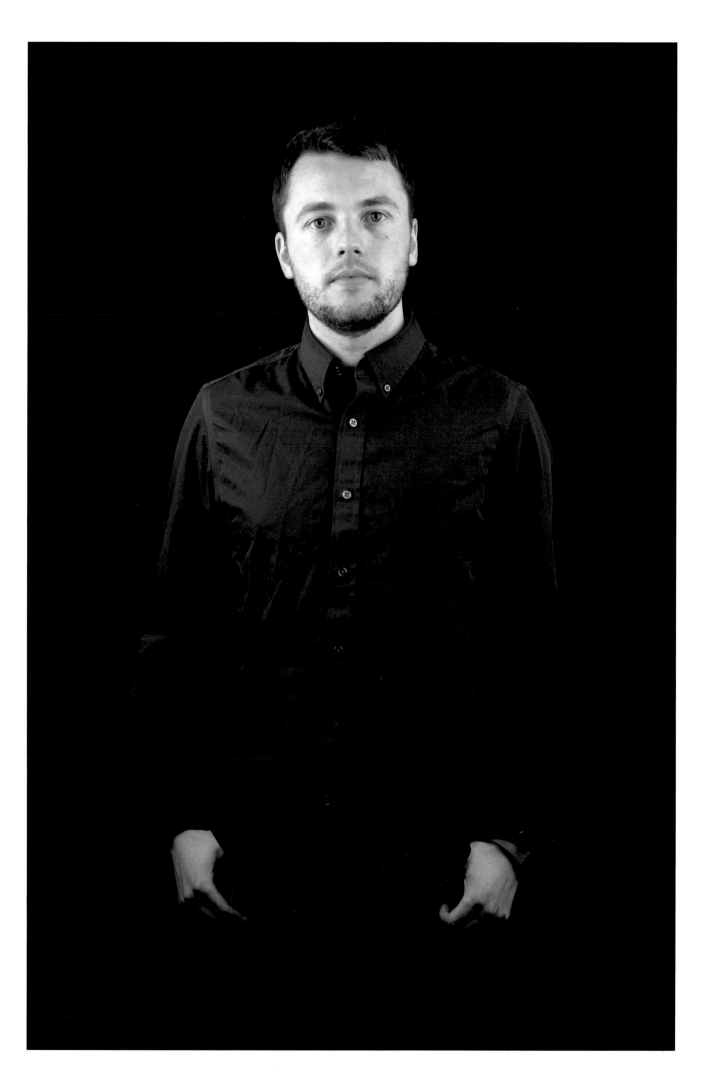

It was April 15, 2013, and it was my twenty-second birthday. I had just made the decision to come to MIT. I was in class in the morning, and we learned that there was a terrorist attack in Boston. It's strange for me having a connection to the Marathon bombing without actually having been here on campus.

I went to Carleton College in Northfield, Minnesota. My major was chemistry, and my minor was in women's and gender studies. That's where I began to realize that I had this sense of duty and responsibility that led me to being the president of the student association there, and later to my current role of Graduate Student Council president here at MIT.

One of the first things I did in the summer before I came to MIT was to make a plan for myself. In my first few weeks at MIT, I was going to go to MIT Mental Health, so that if an issue ever arose, I would have somebody here who had seen my face and talked to me before.

I sort of knew, but I had never really come to terms with the fact, that I had some sort of mild obsessive-compulsive disorder. I grew up in suburban Missouri. Different parts of the country are different with respect to views on mental health. There, people think you should pick yourself up by your bootstraps, and you can figure it out.

I'd never thought that most people aren't keeping a running tally of every step that they've taken when they're walking around. Anytime I would see a phone number in public, like on a billboard or something, I would just in one quick swoop sum all the numbers. It didn't mean anything. Oh, there's a phone number. OK, 45.

When I was most stressed, things got a little bit worse. As an undergrad, I was very busy being the president of the student association, writing up my senior thesis and taking a lot of challenging classes. I might be in a meeting with somebody, with my advisor, let's say. I'm sitting there and I just sort of have this running conversation in my head, thinking, "What's the worst thing I could say right now?" Something that would just ruin my professional life, such as standing up and swearing at my advisor and walking out.

Of course I never acted on those thoughts, because, ultimately, I'd like to think that I'm a good, nice person and I wouldn't want to hurt anyone. A lot of people have intrusive thoughts enter their head, but there's a filter, and most people can let them go. I would sit there and be worried. My hands would start getting

cold because there was always this gripping fear in the back of my mind. What if I actually did it?

One of the things I do best is getting other people into the mindset and into positions where they feel like they have adequate support and resources so they can do their best. Trying to square that up with the terrible thoughts inside my head was very difficult.

About half an hour before I went into my meeting at MIT Mental Health, I made the decision. I'm just going to talk about this, I said to myself. I'm just going to say it, and I'm going to have to face this fear, this anxiety of talking about something that might potentially be very sensitive. In the end, the discussion went fine, and they suggested I talk with someone who deals with anxiety and obsessive-compulsive disorder. At the time, I lived in Brookline, so I started meeting with someone there about once a month.

I saw her four or five times. Simply talking about all these little behaviors and patterns that I had made me feel better about it. I went to Ireland that summer to measure isotope ratios of nitrous oxide in the atmosphere. I was at Mace Head, in rural Western Ireland, and I was too young to rent a car. I had to bike many miles to get anywhere.

There was no real grocery store nearby, so I ended up eating just about the same thing every day. It would be oatmeal and an egg in the morning, a sandwich and an apple for lunch, and then steamed frozen broccoli, rice and smoked salmon every night. Some people couldn't stand eating the same thing day in and day out. The good thing is I don't get bored with food. As an undergrad, I ate the same breakfast every morning: oatmeal with peanut butter, and eggs with Tabasco sauce.

When I came back from Ireland, I felt like I was in a much better place, and I didn't need to continue talking with the therapist in Brookline. Going to that first meeting at MIT Mental Health was one of the better decisions I made since moving here. All the changes that I've made, and coming to being more open with people about these experiences—everything that has followed from that decision has been transformative in my experience here.

I still get anxious when I'm stressed. During our general exam process, I was working with an instrument to look at properties of simulated clouds that form on Mars. It was late at night and I just wanted to get one more point of data out of it, but I had to check something on the inside of the instrument. I didn't realize how heavy the part was, and I dropped

it, snapping some wires. There were things that I couldn't really handle, in that late-at-night, tired, really wound-up state. So I sat down for 15 minutes and didn't move. I was sort of overwhelmed. I wrote an email to the post-doc saying, "I think I broke something. I'm going to deal with it in the morning."

I don't get troubling thoughts nearly as frequently now. But yesterday I was in a workshop and something did come up. One of the people that was putting on this workshop—in my mind I was saying, "This person's the size of a whale." That's something that's really hurtful. I just thought, "OK, that's destructive and that doesn't represent how I try to interact with people." I can let it go now.

When I'm walking around now, I'm no longer counting steps. I live in Jamaica Plain, so it's only 45 minutes or so to get here every day. I listen to a daily podcast about baseball. While I'm intently trying to listen to that, I'm not counting. It's more productive to get up-to-date news on something that I care about, rather than wasting time and counting numbers. Somehow the phone number thing sticks with me, though.

I'm sure that everyone's experience is different, but if there are things that are disruptive, I think there are a lot of different things that you can do to make them less disruptive, less interfering in your life. Just talking to someone about it rather than just keeping it bottled up is really liberating. Even just a check-in with friends, having an honest conversation about things that are happening in your life.

One thing that has really helped me in my time here has been doing something active for an hour or so a day, scheduling myself every single day that I can. Somehow all the loose nervous energy that was causing issues in the past is more constrained.

We're all in this together. Sometimes people ask me what my favorite thing about MIT is. I really enjoy our departmental Cookie Hour. This is endowed; there's money in it that's going to make sure it goes on perpetually. Every day, at three o'clock, we have cookies and fruit in our lounge. I get to see everybody almost every day. I'm sure—beyond all doubt—that all the people eating cookies are dealing with issues of their own. I hope they feel comfortable confiding in someone. If not, I hope just eating cookies and cherries with friends is as much a daily highlight for them as it is for me.

Michael McClellan is a graduate student in Earth and Planetary Sciences, and president of the Graduate Student Council.

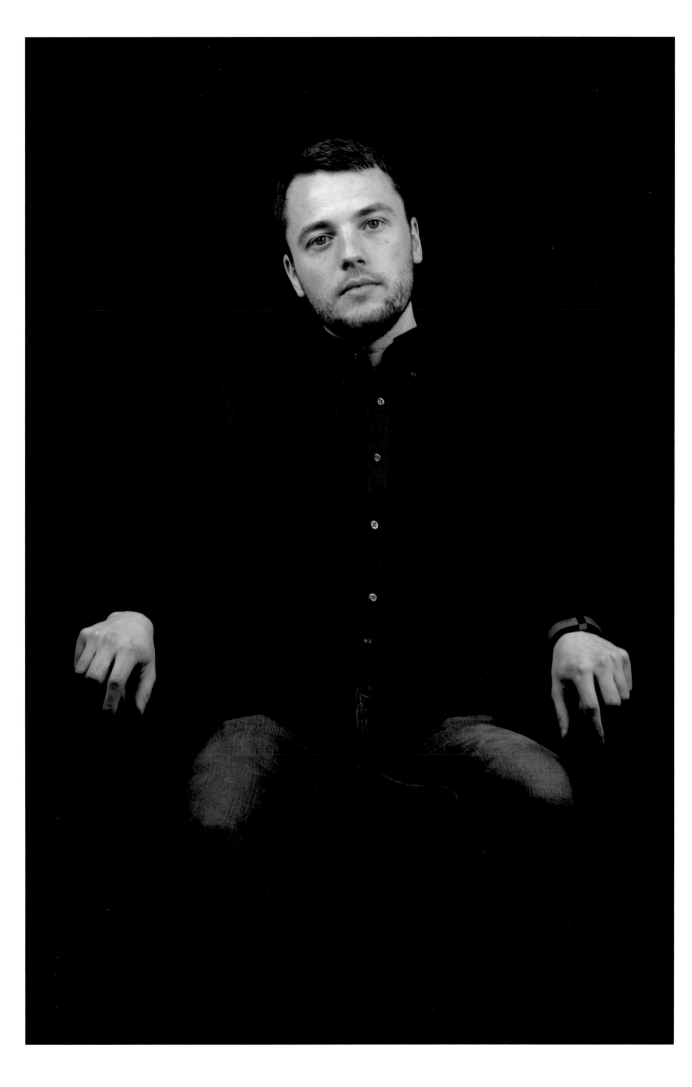

ROSALIND PICARD

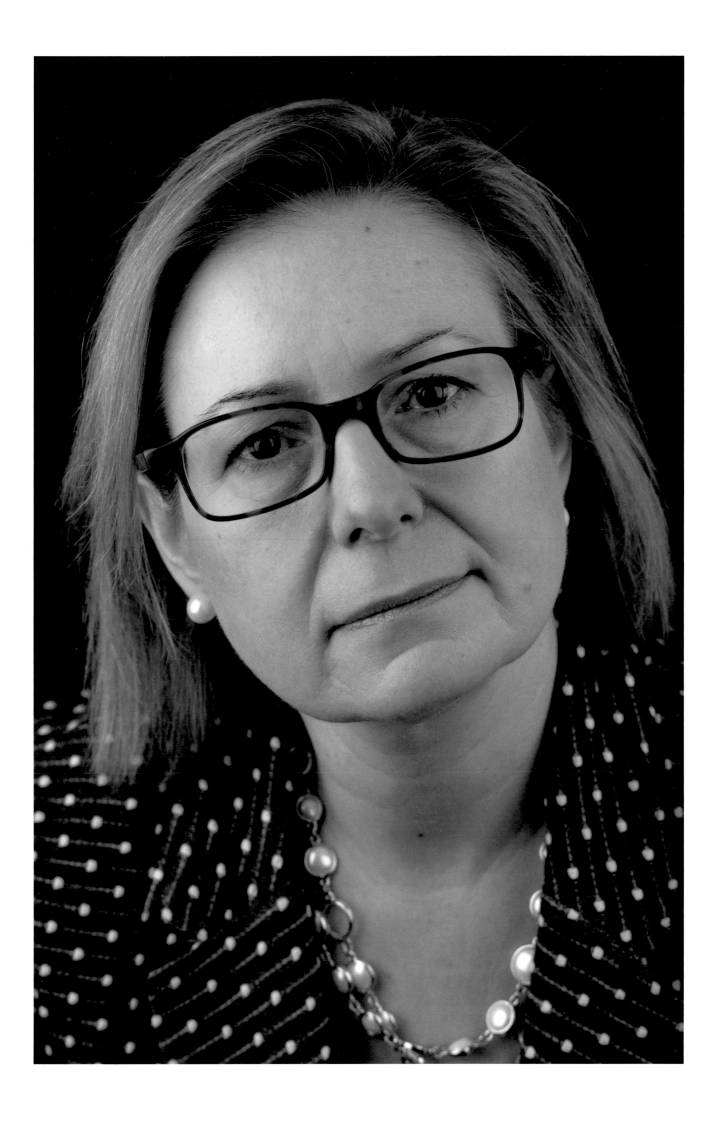

I've had three episodes of depression that stand out in my life. One was toward the end of my undergraduate career. I was an electrical engineering major at Georgia Tech. When people would take their minor classes in easy topics, I took nuclear astrophysics and stellar evolution. I was taking six EE and physics classes and doing several extracurricular activities. It was insane. I managed to finish number two in my class. The guy whom I'd tied for number one in high school became number one.

I loved my work, but I became a working machine. I thought I needed only enough sleep to stay awake. I used to fall asleep in my history class after lunch, which was bad. I made a B in history. I thought that's why I lost my number one spot.

I had no idea that anything was wrong with me, until the end of my senior year, when my closest friend and roommate pulled me aside and said, "I'm worried about you." I was sliding down a scale from being somebody who was usually very joyful and happy to being somebody who wasn't feeling much joy and was very irritable.

Anyway, it was close enough to graduation that I got through everything and felt great again. I came to grad school at MIT in electrical engineering and computer science. I loved it here. I was not grade driven; I was much more driven by wanting to learn new things. It was paradise. I worked as hard as ever, loved it as much as ever, and things were really going well.

Then I got married. I was certainly happy to get married, and my marriage is fabulous. But that first year of marriage was the toughest year of my life. We were living up in Wilmington, so I was spending all the time in a car, instead of walking and biking, and I took the hours of commuting off my sleep.

I became really depressed that year. I had every logical reason to be happy. I actually loved my work, but it was like there was no joy. I would wake up angry for no reason and wonder why I could not make myself feel happy.

I had the first thoughts of suicide during that time. That's when I started really worrying about myself. I had this image of approaching a cliff, and I would get near an edge and I would panic. I felt like I was getting so close to it that if I looked over it I would fall, that I was going to let myself slip. That was a very scary feeling.

As an undergrad, I had become a practicing Christian, and I thought that killing oneself was wrong. My husband also thought it was wrong. I remember that, at that moment when I didn't care anymore, there was a little voice tugging me a little bit away from the edge. I felt that no matter what I wanted, there was a greater source of knowledge saying, "This is wrong," and that I would benefit by listening to that.

To my husband's credit, he was wonderful and supportive, and I had amazing good friends who helped me through this, too. This was the first time I got counseling. One of the things the therapist suggested was that maybe the hormones I started taking when I got married were making a difference. I stopped taking the pill, and I started feeling better almost instantly. I started feeling like my old happy self again.

I got my PhD; I got hired by MIT; I got promoted; I got tenure. All was cool. We started a family. Son number one, great. Son number two, great. Son number three, I'm lying there over at MIT Medical, and they're checking on me, and I'm blessed with healthy children, healthy marriage, everything's great. Doctor says, "How are you doing?" Tears just start rolling out of my eyes.

Once, a friend of mine who was going through a really tough situation said he felt like he had been asked to climb Mount Everest, and only been given a bathrobe and slippers. I felt like I was being asked to climb a little personal Everest at this point, and I just didn't know what lay ahead or how to prepare for it.

The doctor said, "You know, I think it might do you some good to talk to somebody in Mental Health." I went to talk to a therapist a couple times, and it was wonderful. She laid out the emotional trajectory of what was likely to happen. It's as if somebody asks you to sing a song you don't know, and they don't give you the lyrics. You're kind of stumbling through, but then if they give you the lyrics and you can read them first, and then sing it, you do a little better. I could now see, "Oh, yeah, it would be normal to feel that at this point." Instead of just being broadsided by a set of feelings, I'm able to step back and say, "Oh, I know now what's going on and I can manage it."

It was resolved within weeks after I went to talk to her. It was amazing. In that case, it was just a cognitive thing. Perhaps the hormones were bringing it to a peak, but it was more that I had not prepared myself mentally for what I was getting ready to go through.

Depression isn't just one thing. Sometimes it's biochemical. Sometimes it's exercise and sunlight. Sometimes it's sleep. Sometimes it's cognitive thinking that you need a little help debugging, ideally by somebody who has the words to what you may have to sing.

Now I see it as this juggling act of figuring out what my priorities are, keeping them straight, and, also, having really great friends who help keep me accountable to that. My Christian faith has made a huge difference in my life, too. It's not just a set of beliefs. It's a set of practices.

I'm an extreme introvert. I would be very happy just curling up with a book and the Internet permanently by myself. But the Judeo-Christian scriptures tell you to put others before yourself, and to go out and love other people, even those who we think are unlovable. I fail a lot, but when I have those momentary successes, it's amazing for my mood and my well-being, as well as perhaps making the world a little better. I don't want to think I'm doing it for selfish reasons, yet I feel like I benefit more than I deserve from some amazing relationships. Social relationships are good, even for introverts like me.

Often we're focusing on ourselves—on our own sleep, our own health, our own mental thinking, and all of this is important. Taking care of one's mental and physical health is number one in order to succeed at anything. But to exclusively focus on yourself is unhealthy. For those of us who would just live in our own worlds and do our own work, being strongly encouraged, even admonished in some cases, to get out of that cocoon and reach out to others is incredibly beneficial, not only for our community, but for our own well-being.

I do a lot of research with neurologists and psychiatrists, and I was meeting with the chief of pediatric mental health at a major hospital in the UK recently. After we finished a discussion of neurophysiology, I was rushing to my next meeting. He said, "Wait. Do you know the most important thing for children in preventing suicide?" I stopped in my tracks and said, "No. What?" He said, "It's having a family with strong religious faith."

After that, I went back to the people who did the Healthy Minds nationwide survey and said, "It had a couple questions about religion. Did we have any significant difference there?" They said, "Oh, yes. It's well known," and sure enough, the MIT numbers and the national college numbers show huge statistically significant differences. Students who have regular religious practice are more mentally healthy.

I grew up as an atheist, and I know religion is not a comfortable topic. And religious practice is not the only protective factor. But at MIT, we have to talk about all these pillars of well-being. It's time to do the science to really understand what regulates mood—up and down. We don't want to take away Everest: That wouldn't be MIT. We want to climb something even bigger than Everest, but we want to succeed and help people succeed in doing it. So how do we do that?

Rosalind Picard is Professor in the Program in Media Arts and Sciences, and Faculty Chair of the MIT Mind-HandHeart Initiative.

DYLAN SOUKUP

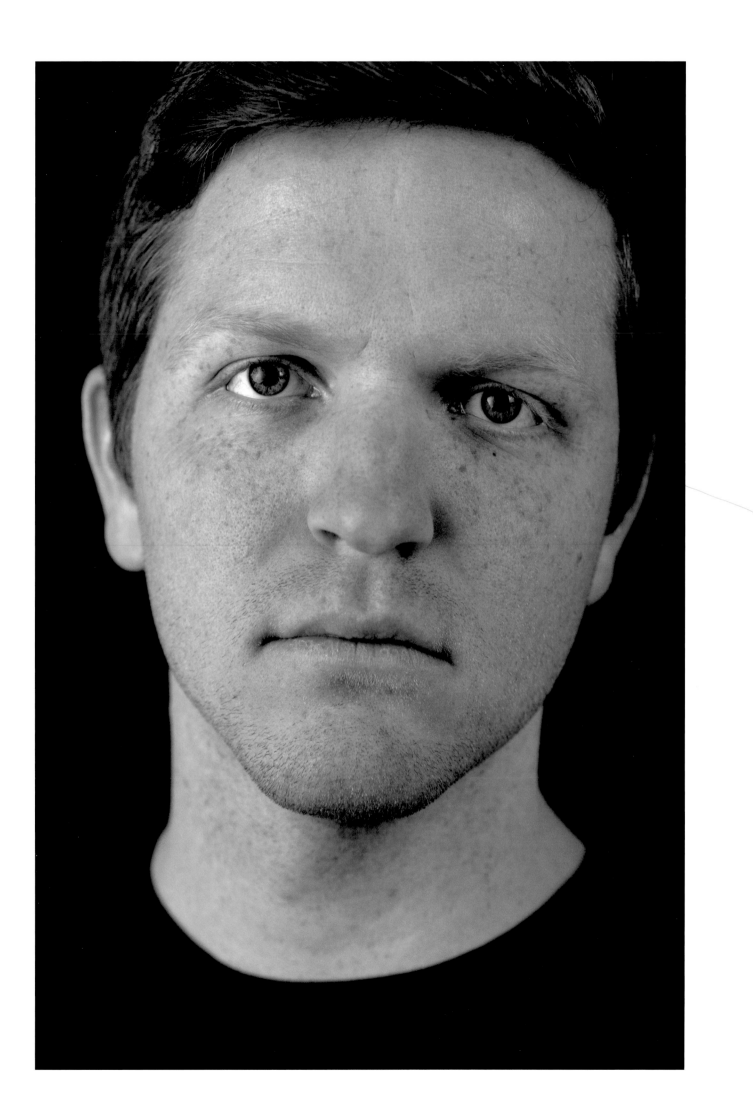

Since I heard about this project, I've been thinking: what is resilience? Am I resilient, and if so, in what ways? I've spent time reflecting on the various events that have happened in my life. My story begins when I was diagnosed with cancer at a very young age, when I was an infant. My mom's protective of me even now because she's been afraid of losing me, ever since I was 5 months old. It's something I don't remember.

It lasted for about a year, and my family spent a lot of time in the hospital. My brother was 6 then, and he went to a camp for kids with cancer and for their brothers and sisters. Later, he would tell me about the fun he had there, so when I became old enough, I was able to go to the camp too.

I loved the camp because it was camp—a ton of fun, all the outdoor activities. It wasn't until I became 11 or 12 that I started to have a little bit of maturity to think about what my peers were going through. Eventually that became the topic of my application essay to MIT, and it's the inspiration for why I'm now in the medical field.

In that camp, I learned so much more from my peers than I ever gave to any of them. It opened my eyes to a world I would have never known had I not gone there. I went to the camp up until I was 16, and then I became a counselor. As I grew up, I had many friends who passed away from cancer. I'd met them at camp and seen them in the middle of treatment, as they were getting treatment while at camp.

The whole camp became like a family. When someone passed away, often we all knew. Or we were coming back the next year and saying, "Where's Jeff?" Sometimes not even knowing, did they pass away or did they not?

We were able to talk it through, in those little moments, in between campfire and dinner. I don't want to say it was counseling, but in a way it was. If you put a group of people who are struggling with something together, and if they're open and start talking about it, you find that you help each other along by simply being there for each other.

I have a list of stories that I've come across in my life. I keep it in my back pocket, in a sense. My resilience wallet is what I call it. To me, it was starting to see each of these stories, like you're doing with this project, how everyone has a different perspective, and how different people deal with different things.

One camper in particular sticks in my mind. He was struggling with a brain tumor and could barely hold his own balance. I remember him stepping off the bus and not even being able to run over to the group like all the other kids, to be excited. He was just standing there and needing help walking. One side of his face drooped, but he made this huge smile.

Along the way, I had other people who were diagnosed with cancer. My sister was recently diagnosed, and had surgery, a double mastectomy. She's doing better now. When my brother was going through my experience with cancer, his kindergarten teacher ended up being almost a mother to him, helping him out in so many ways. When I was in kindergarten with her, she ended up having cancer and passing away that year. I was 6 at the time, so I was oblivious to it, but a couple of years later I started to think back and say, "Wow, what a full circle that is, to have her help my brother out, and then for me to be there, and her offering the same gift of teaching to me, and then passing away."

I was about halfway through high school when it dawned on me: I want to be a part of cancer research. I want to do something to help these people out. That was my way of paying back for having been given the camp, having been given the campers' stories.

So I came to MIT, and I fulfilled my dream of doing research. It's funny, but working at the Koch Institute almost ends up being small compared to the stories of my friends and everything, and in the impact that they have had. The cancer research itself, the science of it all, is fascinating, and I know it has an impact, but it's being up close to the people that is why I'm in medicine now.

Here at MIT, when I found out about a different camp, Camp Kesem, I said, "Wow, this is something I need to be a part of." It's for kids whose parents have cancer. One after another, I came across kids who had gone through hardships that I can't even imagine. I continued to file those stories away in my resilience wallet.

There are all the medications in the world that we're trying to develop for PTSD, for depression and stuff like that, but those will take you only so far, and they don't work forever. In a sense, over time, I've been building the practice of cognitive behavioral therapy on myself, by listening to other people's coping mechanisms. Can I articulate them in words? Not always, no. But I do know that now—when it comes to dealing with the difficulties in my life, most recently my father passing away, when it came to the Boston Marathon bombing, when it came to losing a camper—that those are all moments when I just kind of sit back and I'm comfortable at that moment with being open.

I met Sean Collier six months or so before the bombing. We didn't have the time to develop a deep friendship, but he was a friend in the way that people who work together in tough situations become friends. Sean was the kind of guy who became a friend from your first interaction with him.

He was a community police officer. I was an EMT working on the MIT ambulance, so we were colleagues. We would show up on calls together. About a week before the incident happened, he was in our bunk room, and he had just gone off shift, so he was tired. Any other police officer would head home, but he decided to stop by and visit the EMTs. We were planning for our next practice drills. He saw us struggling to plan some stations, so he said, "How can I help? I don't know what I can offer, but let's talk through some of these." He became one of us.

Once there was a family in a graduate dorm with a baby who was struggling to breathe. The ambulance wasn't on scene, but Sean had an oxygen tank, and he climbed across the bed to provide oxygen without disturbing anyone. He helped get the baby down to the ambulance and to the hospital. After his shift was over, he went to the hospital to check on the family and then took the time to come back to the ambulance crew. We never get to follow up on our calls, and he came back to the bunk room just to let us know that the baby had done well. It's not remarkably huge things, it's those small things that made him one of us.

Every year, at the Boston Marathon, we did a fundraiser for Camp Kesem, along the finish-line stretch. For whatever reason, I decided that it was time to go home. I had just walked back across the river and was back in my dorm when I heard what I thought were cannon shots across the river, and then I saw plumes of smoke. Then the emotion started setting in, not the PTSD of having been there but the "what could have been?" scenario playing in your head, and wondering if my other Camp Kesem friends were still there, frantically trying to call them as the cell towers were down.

We lived in this MIT bubble, and never did it cross my mind to worry that the bomber was still out there. Boston was more tense, a little on edge, and as the days ticked by and the search intensified and pictures were released and everything, it became a more intense situation. It was a raw week, thinking what could have been, and asking myself "Why wasn't I there? I'm an EMT, I could have been there and helped." Stuff like that, replaying.

So that was the kind of emotional state I was in on Thursday when I was on shift, and we got the call for an officer down. I'd never had that type of call before. We're community EMTs, on a college campus. You don't have much happen. People think EMTs have crazy emergencies all the time, but we don't.

Thirty minutes before, we'd waved to Sean as he parked his car right next to the ramp where we exit, doing the usual flashing of the lights and saying, "See you later this evening." When we got the call, we thought, "What on earth happened? That's Sean. It's got to be Sean. Who else could it be?"

When I got there, we looked at each other as if to say, "It's Sean. We're going to do everything just like we always do." I had never responded to a shooting before. I had never responded to a cardiac arrest. That was the first time that I truly had anything that dreadful. I'd never been so close to terrorism in my life. But in that moment, when you're first confronted with the call, you ignore those emotions.

We had trained for this. It was one of those scenarios where you have, however small it is, some chance of doing something. When you have a traumatic cardiac arrest, at the end of the day, the statistics show the outcomes aren't good. His fellow officers were there too doing CPR. He wasn't alive at that point. We were doing it for his family, and for his fellow police officers.

We transported him to the hospital. I was the crew chief at the time, so I was the driver and my fellow EMTs were in the back with the paramedics that had responded from the Cambridge fire department. We didn't have room for more people.

As I was driving across the river, there was a sea of blue lights speeding in front of me to block off every road. I felt like I was in a presidential motorcade. It was a surreal moment. We were flying to the hospital, but all the while, coursing through my head at the same time was, "Don't let the nerves get the best of you. You have four other people in the back of the ambulance. Driving safely is number one. If you don't get to the hospital, then nobody gets to the hospital."

I had driven over to Mass General hundreds of times, many times on calls, and many more on training runs. So we ran it like any other call. It wasn't until after we got there, gave the turnover report, and moved him onto the hospital bed, and when they pulled the curtain to start doing their work that my two fellow EMTs and I stepped back. Everything

started to hit at that moment. We were staring at a wall for fifteen minutes, or however long, while they were working on him, until they officially declared him dead.

We turned things over to the City of Cambridge to respond to any other calls that night. We went out to the ambulance to find one of the other paramedics trying to clean up the ambulance and we said, "You don't need to go through this. We have people back at MIT who are going to help us out."

Coming back that night, the first thing we wanted to do was go home and wash. Not to wash away the scene, but so much had happened. I felt, "I want to go home and shower. I want to reset myself to human mode, because right now I'm not in human mode."

We took turns driving. We'd drive the ambulance and go to one dorm, go in and clean up, and then go to the next dorm. It was while I was sitting there waiting for one of my friends to shower that I decided to call my mom back home, and tell my family what had happened. "You're about to hear a lot of news on national TV about what's happening in Boston, and I want you know it's on MIT's campus, and that I was a part of it, but I'm fine now. I will tell you more about it later."

Back at MIT Medical, we met up with the chief of the emergency service, who had also been a friend of Sean's, and then the other EMTs and our technical advisor. One of the doctors came in from MIT Medical and issued benzos in case we needed them. We went to a room on the fourth floor in the former inpatient ward, just to sit and hang out. We decided to stay there the rest of the night. We wanted to be together, to be able to talk through things.

That's when we had our first debrief, just to talk through how each of us had seen the situation, so we had the facts straight in our heads, before we started making things up and remembering it differently. It was one of those times like I talked about earlier, where we were counseling each other without even knowing, just being there.

That night was a foreshadowing for the whole next week, and that was how I got through the whole thing. There were people around me at all times who were very supportive. Sometimes I needed to go home, and just get away from people for a few minutes, and shower on my own. Just being able to turn to my fellow EMTs, who had gone through the same thing, and talk to our chief, Annie.

Annie was a year ahead of me. She hadn't been on shift that night, but we called her and said, "Put down your problem set. You won't be needing to do that. You're going to have reason to be with us for the next week." She had been our last stop that night on the way to MIT Medical. She ended up sending out an email after that night to all the EMTs, to say what had happened, that Sean had been killed.

In a follow-up email the next day, she said so openly, "I called my mom and was talking to her, and in that moment I realized that I was not OK and I needed to be seen at Mental Health, so I took myself and I went, and I talked to someone."

It ended up being event after event, which became a little overwhelming. There were so many people having opinions about what was happening, and the whole country watching, and Joe Biden giving a speech. It was just good to have people who were willing and able to be there for you.

At no point did I seek out formal mental health treatment, but at the same time, if I look back at it, I had mental health treatment, in a way, through my peers. I had counseling over and over again in those little moments where my peers were able to be there for me, to talk through how they were dealing with it, what their emotions were at the time, to compare them to mine, and to know, in the end, that they were all OK emotions. We were so fortunate, having been student EMTs and being on campus here and having each other, to be able to get through such a horrific event. We still text every once in a while, on the anniversary or whatever, just to check in on each other.

I learned how different humans are and how we cope differently, and at no point is it wrong to grieve in a different way than somebody else. I carried that over then to this past year, when my father passed away.

I never got a chance to say goodbye or anything. I didn't even know that he had any health issues. He didn't even know that he had any health issues, until one day he was at my mom's house. My parents were divorced, but he would go over to help her out with stuff, and so he was helping her with the yard and then came into the house, sweating profusely, and said, "I think I'm having a heart attack. Let's go to the hospital."

They rushed him in, and I started getting these phone calls, updating me: first that he was having a heart attack, then that it was just chest pain. Then they took him to the catheterization lab, and because I was in medical school, I was thinking, "Perfect, going to cath lab, he'll be fine. They're really good these days at doing that, stenting it and moving on." Then I got

the call an hour later from my brother, saying, "Dad coded. He had a cardiac arrest in the cath lab." By the time I heard that I was, like, "I'm on a plane." We thought he'd be in the ICU for a week or so, so I flew back home to be there, to help him. He just never woke up from it.

Time after time, I keep falling back on what had happened before. I'm equal parts fortunate and unfortunate for having had these events happen: each one can help me with the next one.

What we're lacking, in some respects, here at MIT, is the ability for people to develop their own resilience. You can't develop your own resilience, your own stories, if you don't have the stories being shared by others, if you haven't seen other people struggle through something. That's how we fall into imposter syndrome, thinking you're the only one struggling, that you're the only one who hasn't finished the problem set.

It's not just here at MIT. I'm experiencing that now in medicine. There are studies coming out showing that physicians have some of the highest burnout rates ever. You'd think, "They're medical professionals. They should be able to talk. They should be able to help each other out." But that's just not the culture. It's not the culture at a place where people are driven, always trying to achieve higher and better, and trying to outperform one another.

Technology is moving faster than we are in our human interactions. Some of the best leaders have very little technical expertise but have the ability to bring people together. Why do we value that so much? I think it's because that's something we're constantly striving for. And despite having all these things in life that have happened around me, it's something that I'm still trying to develop.

Dylan Soukup, Class of 2014, is a student at the Mayo Clinic School of Medicine.

SALLY LEE

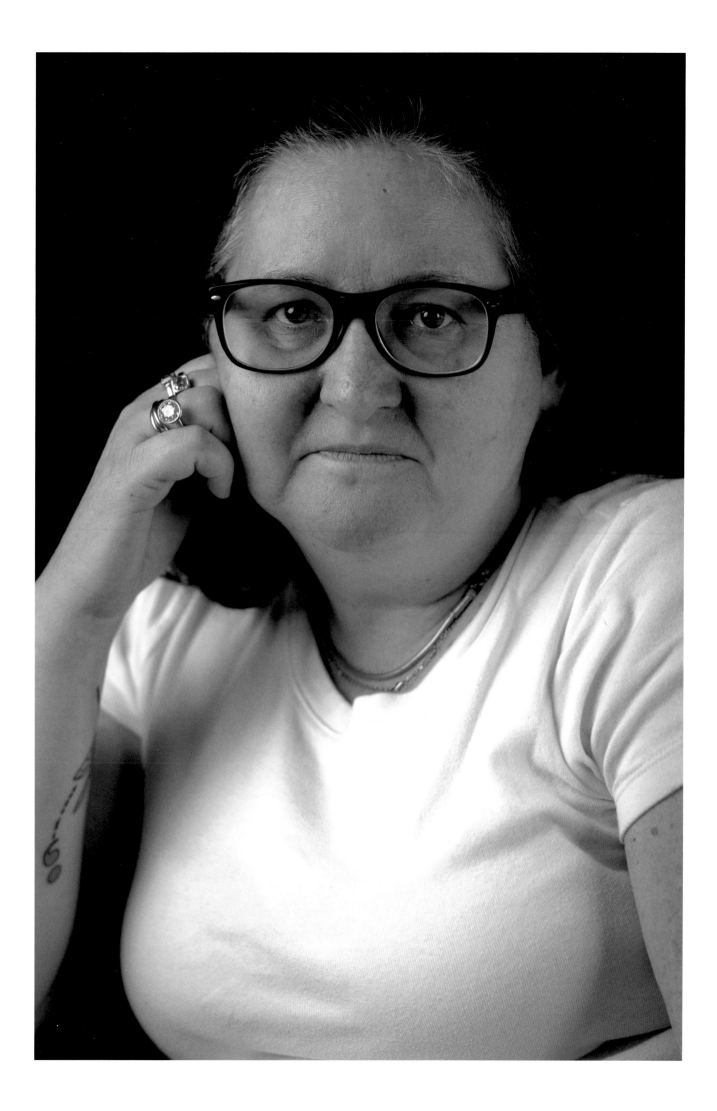

I came from a troubled home. We were comfortable, and there was love, but there was a lot of uncertainty. It all looked good. The hedges were trimmed, the car was in the garage. But there just wasn't a lot of unconditional love. There was never just buying you a new dress because you're you. You had to give a lot of love to get any in return.

I was depressed during college, on and off. In my freshman year, I was in a relationship that ended abruptly. I went to a therapist. He said, "Are you pregnant?" I said "No," and he said, "Well then, you're fine." And that was the end of that. Somehow I pulled myself out of that depression. I had really good friends. I fell in love with art, and I had teachers who told me, "You know, you can probably do this with your life." And that helped.

I lost the hearing in my left ear at 24 and started suffering from tinnitus. I became very sick. After exploratory surgery, the doctors said there was nothing they could do. I was living with friends in Watertown, going to graphic design school. I moved back to my parents' house, and the depression was far worse. I had some money from my grandmother, so I moved down to New York for a year, to go to art school, to just paint and draw. And then the money ran out, and I was getting more and more depressed. I moved back home, and now my parents were worried about me.

I eventually started to get help and was on the road to recovery. I had many issues, so I dealt with them one at a time. I was still depressed but I didn't understand it as an illness. I thought it was my fault and that I needed an attitude adjustment. I eventually got a job and moved out on my own.

And then my mum got sick with a tumor. She was diagnosed in January and she died in August. And my dad had already had a stroke. I was the child closest to home, so I had to look after them. As much as I loved my parents, their problems were more than I could handle. I just lost it.

I got more and more depressed. I couldn't sleep, I couldn't eat, and I lost 20 pounds. I didn't know what was wrong with me. My friend Sue said, "I'm worried about you." After a few months, she and her husband called me one night, and they said, "We're worried about you." They said, "We think you're going down."

The next day I went to see the psychiatrist on call at MIT. I said, "I'm really not OK, and I think I need to check into a hospital." They got a bed for me that afternoon. I stayed four days, but the medication wasn't right. Six weeks later I went in again, and they nailed it. This little hippie therapist said, "Sally, you know, normal people are here"—he had his hand up by his eye—"and you're here"—and the other hand down by his chest—"and this is all we're doing," and he lifted one hand up to the other. And I said, "That's it?" And he said, "That's it." I knew then I was going to be OK, and I never looked back.

I had basically suffered from depression all my life, and this was the first time I didn't have to battle with my brain. I kept thinking I wish I'd done this 20 years ago. I wouldn't have had to suffer so long.

Now I'm just on Effexor, which is like a miracle drug for me. There is so much misinformation—that you're not going to feel anything, going numb. But really all it does is even out all that sorrow.

People who don't have depression have no idea what the depressed person is struggling with. It's like a person sitting in a wheelchair and the thing they would like to do more than anything else on Planet Earth is to get up and walk up those stairs, but they can't do it. And the person who's walking up those stairs just says, "Get up! Just get up and walk up the stairs! What's the matter with you?"

I wouldn't wish this on anybody. Nobody should suffer so long. I didn't feel the answer was to go to a doctor. That may have been obvious to every single person around me, but not one ever said that. I was surrounded by people telling me to not take things so personally. That went on for way, way too long.

I'm glad I lived, you know, because it was pretty dicey for a little while. I am 53 now, and my troubles are behind me. My life isn't perfect, but it is pretty great. Back then, I had a lot of rage and anger. I used to carry all that with me, and I just don't carry it anymore. I said to my therapist, "Is this how normal people feel every day?" And she said, "Yes." I said, "Wow, I had no idea."

Sally Lee is an administrative assistant in the Computer Science and Artificial Intelligence Laboratory.

TAYLOR SHAW

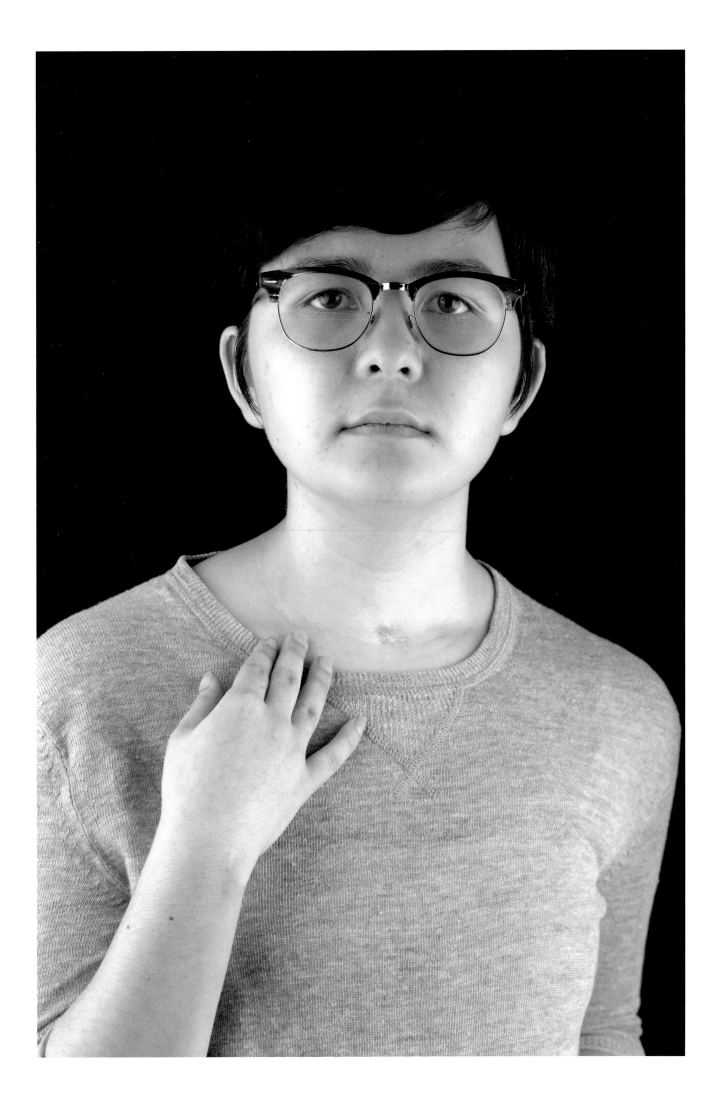

I had started the second semester of my sophomore year, and it was going fine. I had all of the test dates in my calendar. Then on February 22, 2014, I was running with a friend and I had a cardiac arrest. Bystanders called 911.

It took them six minutes to get there. Nobody did CPR on the scene, which would have made a huge difference. Later, it took eighteen minutes of CPR for my heart to start beating on its own. I've heard the brain can actually survive four minutes without oxygen, so any kind of CPR then would have really been useful. That's why I'm a big advocate of CPR.

I was taken by ambulance to MGH (Massachusetts General Hospital). My Glasgow Coma Scale was three, which is the lowest possible. It's based on basic signs of consciousness, like whether or not your pupils dilate when they shine light in your eyes. Because of that, I was eligible for this experimental procedure where they cool your body down. They took an MRI that day and it was normal, because the damage had not hit yet. Then they took it after the cooling procedure, and there was extensive damage in the basal ganglia and the occipital lobe. The damage to the occipital lobe makes it difficult for me to read, even today.

I was at MGH for five weeks. I don't remember that period at all. Apparently I was what they call "storming," which means my eyes were open, and I was flailing my arms and legs around. My prognosis was "persistent vegetative state." Doctors like to give you medication to try to stop the storming, but my dad disagrees with all of that. He found the best way to calm me down was to give me massages and play music to me.

They transferred me to Craig Hospital in Colorado. Craig was really an amazing place. That was when I became aware. The sense of loss had not hit me yet. I was kind of just, like, OK, this is what I have to deal with.

Craig is a rehab hospital. There are three major disciplines—speech, physical, and occupational—and I experienced them in that order. At first, I would stick out my tongue for "yes" and close my eyes for "no." I wasn't able to move my arms at all or my legs at all. I remember my face used to itch so much. I would close my eyes and say, "You know, if you tell yourself it doesn't itch, it will stop itching." Vision fell under occupational therapy. I described it as rain falling on a car window—things were blurry and moving.

When I first started eating, I didn't like it. I thought, "Just keep going with the G-tube. I'm fine with that,"

because it was a lot of work to chew. My big goal after I got to talk and eat was to walk. I incorrectly believed that if I could only walk everything would be better. I remember when I first stood on my legs for the first time. My hamstrings hurt so bad. My goal was to walk out of Craig, but when I left I needed a walker and my physical therapist to help me.

I went back to LA, where I'm from. At first I went to Rancho Los Amigos, which is really well known in the business. The problem is that the wait lines are forever—it's like going to the post office. One of the reasons I got in so quickly was that one of the higher-ups was an MIT alum. I think she pulled some strings. I went to Rancho twice a week for two-and-a-half months.

By September, I could walk and go to the bathroom by myself, which was a big deal. I wanted to move along faster, so I made the decision to stop going to Rancho and start going to this other place called CNS, the Center for Neuro Skills. CNS was for-profit, so that's kind of iffy. Less quality but more quantity. I went there for five days a week, six hours a day.

Then I started at Santa Monica College. They have a brain injury program, and they're very good with the accommodations. I took two classes. One of the classes was training me on technology. I have a program on my computer that reads to me. The other one was kind of a joke class. It was very easy, but in the beginning it was good just to have to go there on my own, sit in class, and do these things independently.

I came back to MIT last fall. Living on my own was a big adjustment. I do need help still, but my roommate helps out a lot. In the bathroom, I have squeeze bottles for shampoo and soap, and she refills them for me.

Last semester, I started with two courses and I had to drop one. Two was a heavy load, but one was a little bit too light. I'm also going to occupational and physical therapy. I don't go to speech therapy anymore. I still have dysarthria, but it will get better with practice. I do that every day, all the time. My vision used to be a really big, sensitive issue for me. I knew my motor skills were going to improve, but the vision, I didn't know. Now it's improved so much, so it's not a worry.

I've put all my aspirations on hold. I prioritize a lot, so I had to walk, and then feed myself, and then dress myself. I cry a lot when I get frustrated. Usually it's something a ten-year-old or even a five-year-old could do. If I go to a dinner, I'm thinking: is it going to be an issue? I cannot really cut meat yet. So I get upset but I think it's justifiable, and I don't stay upset.

It's hard to make new friends. Partly it's that I feel I cannot make any kind of relationship with a person if they don't know this about me. It's a big part of my life, especially right now. Maybe in ten years it will be a side note.

I've not really looked ahead too far because I'm so focused on getting through each day. I want to finish the semester with two classes and hopefully get an acceptable grade in both. I think that will be a really big accomplishment.

Life gets better if you work at it. If you don't, if you sit on the couch all day, it doesn't get better. But if you work hard, you can make anything happen.

Taylor Shaw, Class of 2016, plans to graduate with her SB in 2019.

THERESE HENDERSON

I was born in 1954 into a large family: seven kids, and I was number five. My father was an alcoholic and was verbally and physically abusive. In a big family like that, it was better to try to be invisible and not be noticed, because when you got noticed, you got in trouble.

I've been thinking a lot about this recently, about feeling invisible. Not to be able to show your feelings means you're not really acknowledging your feelings for yourself, just repressing them and stuffing them down. If you learn that as a child, and then continue doing that for years, you get really good at it.

People knew there was a problem, and they just stayed away. My dad was a tough, nasty creature. He was so mean to people in the neighborhood that a lot of people, even kids in the neighborhood, just didn't want to have anything to do with us. It was really isolating and I didn't have a lot of friends. It was very embarrassing to have such an awful parent. I was ashamed of my family and never brought anybody home.

I always knew something was wrong, that there was a better way to live. I just didn't know where it was or who knew that secret, or who could help me with it. I didn't know I was depressed, or even what depression was. I just knew that I felt crappy all the time: when I was a kid, when I was a teenager, when I was a young adult. I was depressed all throughout my marriage, and I was also angry. I have come to learn that depression and sadness can be covered over by anger.

Once, in junior high school, I was trying to get some reaction out of my parents. It was dangerous to get that attention from my father, but I was a teenager. I was going to do things that teenagers do. I started dating black teenagers. We were not in an integrated neighborhood, to say the least, and my dad was a huge racist. When they found out, it did not go over well. My dad went up to the high school and talked to the principal and took me out of school.

He said, "You're not going back to school." I was terrified. I didn't know what was going to happen to me. What does this mean for my life? What does this mean for my future? You have to go to school. I had no support from anyone, and it was pretty bleak. The school was not coming to my aid. The teachers that I knew, the librarian that I was friends with, weren't coming to save me. I couldn't ask for help. I was ashamed and embarrassed to have such a horrible parent.

I have an older brother who died of drug and alcohol abuse a few years ago. He was the one that was the most abused by my dad, the most picked on. My dad

softened up toward my youngest sister. I'm absolutely convinced that my mother must have made it clear to my father that this child is your last chance to have a relationship with any one of your children, so if you don't do it with this child, then you're not going to have a relationship with any one of them. I have thought about this a lot over the years.

After I was divorced, I had a roommate for a couple of years who was getting group therapy on healing her wounded inner child. I thought this sounded really interesting, so I went to see that therapist, and I joined a new group that she was running. I took to it very quickly. There were things like journal writing with the nondominant hand to access your inner voice. I really liked that a lot, and I still use that.

All of us in the group would go out and buy cheap dishes at thrift stores. Then we would have our date, throwing plates and dishes at the wall. Just to get the anger out, and it was all about our parents. You have to be angry at your parents before you can forgive them. I was raised Catholic. It's supposed to be a great benefit if you can forgive everyone, but you really can't do that automatically. You have to learn how to do that, and I think I have certainly learned a lot about forgiving by going through it, and throwing the plates helped a lot.

I practiced all the new skills I learned with my wounded inner child for four years over and over again, just like you have to do with an actual little kid. She asks the same questions over and over. Is it OK that I feel this way? Did I do something wrong? She tells me how I feel about things even if I am not sure. She will pull up things from the past. I'll say I didn't even know that that was what I was feeling or where that came from.

I think of my inner child as mostly healed. I'm not sure that she will ever be 100 percent healed. I don't have the feeling of the angst. The sadness and the fear and just that constant kind of bad feeling have gone away.

I feel like I got my life back. It's a miracle. My inner child definitely helps me with that. I can access her joy at a lot of things: when I'm walking in the woods, walking down the street, when I see people dancing or singing or listening to music. My life is totally different now. I feel like I'm 16 years old, and I've got the rest of my life to live, and I'm not worried about it. I can enjoy and feel things without having any bad repercussions or anything bad happening to me.

I do artwork for myself, and I draw, sometimes with my nondominant hand. I take such joy in that. It's

been five years since the end of my group, and I have a stack of journals that is growing. I'm just having a great life.

Therese Henderson is an administrative assistant in the Sloan School of Management.

SATHYA SILVA

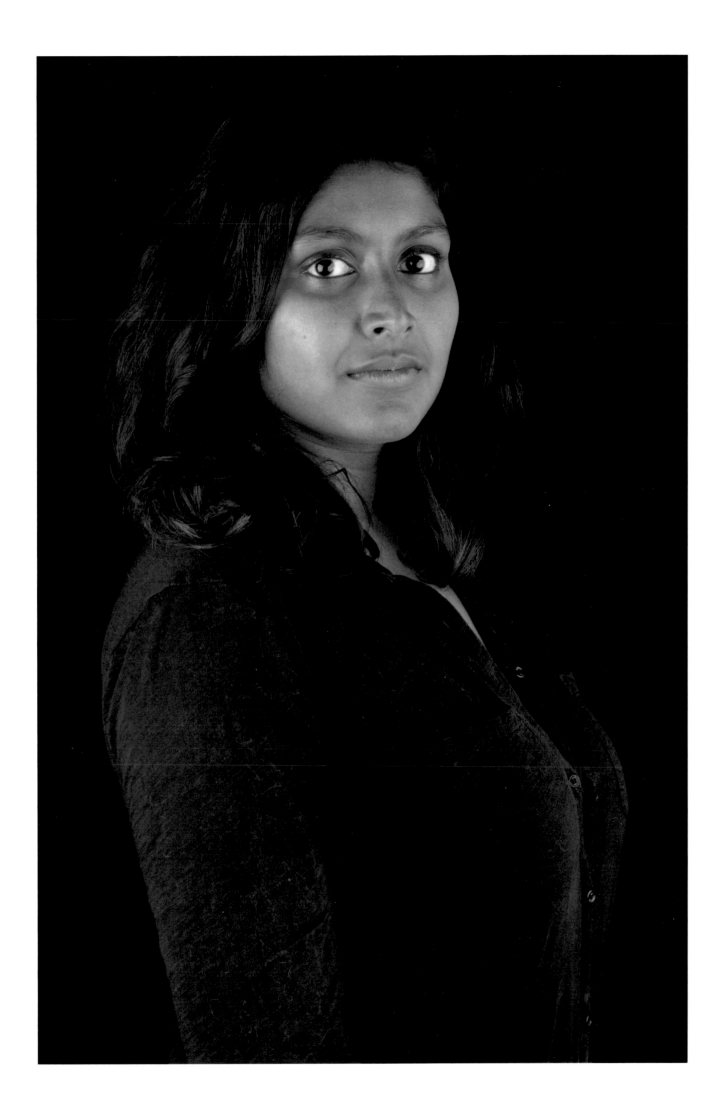

In my youth, I was happy and outgoing. I found my place in the world when I was an undergrad—to be a pilot. I moved to Houston to work in mission control and worked part-time at a flight school. I loved being a flight instructor, but I did have to put up with a lot of demeaning comments. One day, they wouldn't give me a dipstick to check my fuel level with, and they were, like, "Just go."

My time in Houston came with an emotionally abusive relationship, too. We broke up, but that's when the stalking started—continually emailing and texting and calling my voicemail. (It's been seven years, and it's still going on.) The environment in Houston became very toxic for me, and eventually the negativity broke me down.

When I came to MIT six years ago, the change in my personality came with me. At the time, I just thought that it was part of growing up to mellow out and not really get excited about anything. I didn't make much of an effort to make friends and I hated small talk. I got stuck in this catch-22. Also, everyone around me was getting married, and I felt like my time was running out. I got back together with one of my ex-boyfriends, and we got serious enough that we were considering marriage. At some point, I realized that I shouldn't have to convince him to marry me, and that I was worth more than that.

Three years into graduate school, things came crashing down. I had lost all my confidence and drive and everything that makes me who I am. I had become a zombie that saw only the worst in people. Looking back, I can't blame my friends for not wanting to hang out with me. I realized I needed a change.

I applied to be a Graduate Resident Tutor at Maseeh Hall. The first interview was this social, and I was really nervous about it. But I went, and everyone there was amazing, and I felt at home. That community was exactly what I needed. It's full of positivity, and there's so much loyalty and respect and camaraderie. In my position there, I learned not only how to support others, but also how to support myself.

That summer, I went to California for an internship. The change in environment forced me out of my comfort zone and brought back my undergrad self, having to make friends and go out. It was so liberating. One girl, after knowing me for just three days, invited me to go Las Vegas the next weekend. I thought it was crazy, but I said yes, and that trip totally changed my life. She's now one of my best friends.

Coming back from California, I felt so great and confident in myself. There was a faculty position that was open at Stanford, and I said to myself, "You know what? I can do this."

And that's when things started to go back downhill. I went to talk to my supervisor about it, and the first thing he said was, "Well, you don't want to blacklist yourself." Things had been fine with my supervisor for the first few years, but it turned out the new me was totally incompatible with him. I tried to understand where he was coming from, but he used the term "blacklist" multiple times when it came to my future goals. I'd like to think I wasn't a bad student. Why would he continue to have me lead so many projects if I was? But I was getting this type of discouraging feedback while others in the lab were being encouraged to publish, attend conferences, and so on.

I had no idea how to process this difference in treatment. I kept thinking: how could he be so supportive to some students and so demoralizing to others? Was it me? Incompatible personalities? Gender? To this day, I still don't know. I don't think he realizes how much influence his words have. I know I shouldn't take what he says personally, but it wears you down.

The downward trend in my state of mind was exacerbated by another blow later in the semester. I had reconnected with a close friend from college. I remember feeling so warm, and thinking: I've finally got my friend back. Two weeks later, he committed suicide. He had texted me the week before and said he was feeling bad, but I had no idea how bad it was.

When I returned from my friend's funeral the following week, my advisor said, "I know you've been distracted lately, but you really need to buckle down and make some progress." I think it was his way of motivating me, but it had the opposite effect. My grief got tied up in this relationship with my advisor, so any time I thought about work, I would think about my friend's death and vice versa. That's when I started to notice the anxiety: waking up without being able to breathe, constant shaking. Meeting with my advisor, or even an email from him, would set my whole body off in hives.

Eventually things got bad enough that I realized I needed help. I talked to the ombuds, to the dean, to our department head, and to someone in Mental Health. After months of people telling me to take care of myself, I prepared myself to switch advisors and potentially lose five years of work.

The deans had coached me on how to go about it. My advisor's response was, "Oh, you don't need to go. I promise it'll be better." It was a bizarre feeling for me because I felt better, but it also made me realize why people stay in abusive relationships. What had I gotten myself into?

That summer was full of pain, but also so much support. I started going to suicide survivor support groups and seeing a therapist. The housemasters let me borrow their dog who quickly became my best friend. Mickey got me out of bed every day because I knew he was counting on me to go running. My friends stuck by me, and slowly things started to improve. By the end of the summer, I felt strong enough to be able to separate my work from my grief. I got offered a great job and resolved to finish up my degree as fast as I could and get on with my life.

I was able to defend my thesis and am now on my way out. My advisor and I slowly repaired our relationship as I healed and as he became more of an advocate. My friends were there every single step of the way, and the Maseeh community was my rock. A lot of them came to my defense—the students, the GRTs, the housemasters. When I came back and opened my door, my whole apartment was covered in balloons and inflatable airplanes.

I'd say I'm in a very positive place now and I appreciate being surrounded by wonderful people. I was inspired to do something good with my grief, so I ran the Boston Marathon this year on behalf of the Samaritans, a nonprofit that specializes in suicide prevention. It was ridiculously hard, but I pushed through. I feel like I've come so far, and I've finally found myself again.

Sathya Silva graduated in 2016 with a doctorate in Aeronautics and Astronautics and is now a human performance investigator with the NTSB.

CATERINA COLÓN

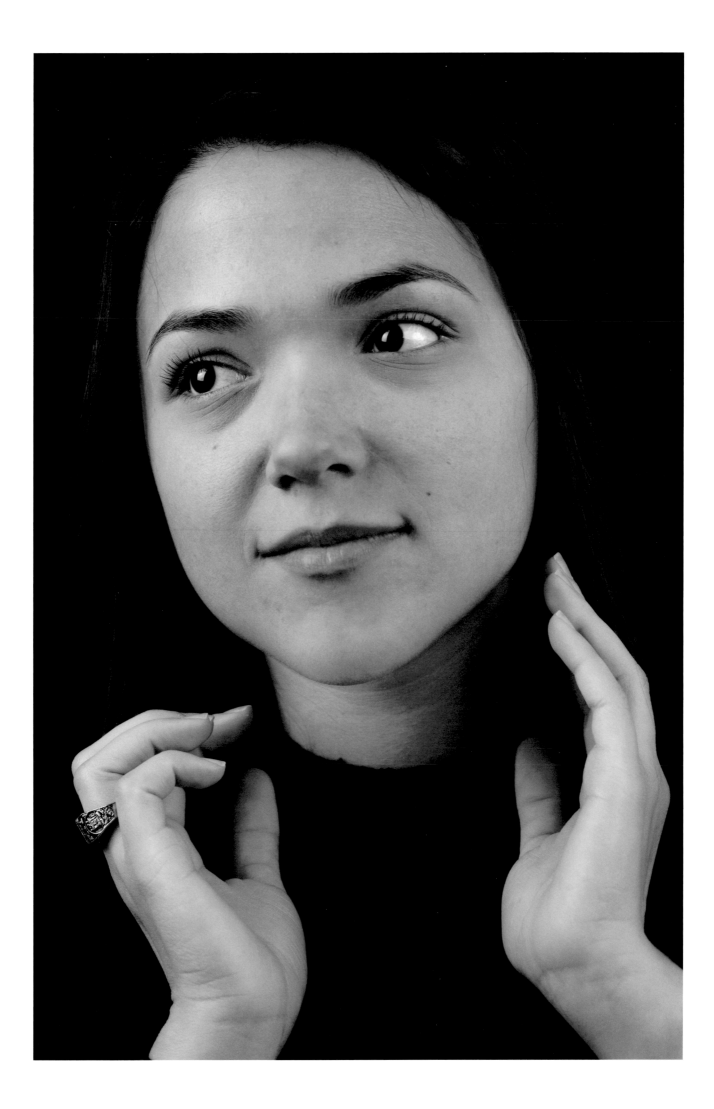

I'm from San Juan, Puerto Rico. My life was pretty stable, and I had always lived in the same house. I'm an only child. I didn't have a dad. I was raised by my mom, and we were very close. We would sing in the car and that was my favorite thing. We sang Italian songs and listened to Pavarotti. My high school experience was very much like other people's here. I was very involved in extracurriculars and different clubs.

MIT was my top choice for college. I got in early, so I didn't even finish my other applications. I was, like, that's the only place I want to go. So I'm about to come here, I had committed a week before, and then my mom had a heart attack right in front of me, and she died. I had to move out of my house that same day. I couldn't stay there on my own. I was 17.

I stayed with my great-uncle or sometimes with my great-aunt. They're brother and sister, but they don't live in the same house. I went back and forth. They were my family.

I thought I was very tough, so I went through with my plans. I told myself, "This is what I'm doing in the fall, I'm going to college. Everyone has to deal with their parents' death, so this is something I can deal with." I think that was a mistake.

The first semester here was OK. I'd cry and I was sad, but it wasn't completely horrible. I didn't join any clubs or anything. I joked around saying, "Oh, I'm too busy being sad." Then I went home for the holidays. When I came back that second semester, that's when I started having serious problems.

I decided to take four challenging courses, all in that semester. I ended up failing everything except for 9.00, Intro to Psych. I didn't even try. I would go to lectures, and I'd fall asleep, and then I'd go home and tell myself, "I'm not going to turn this problem set in because this is wrong." I would go to tests and try maybe a little bit, and then I'd say to myself, "I'm just going to leave it blank, because it's going to be wrong." I felt so completely out of control of my life. There was no escape of where I was spiraling down to. I was so helpless. I thought nobody could help me at all.

On top of everything, I started having flashbacks. I felt so guilty because I was such a rude child. I was sure my attitude had killed my mother. I was very depressed, but at that time I had no idea. I was just, like: well, my mom died. What is the point? We're all going to die. I'm supposed to be sad. I just didn't expect everything to go so completely wrong.

I went to a therapist that summer and she told me I had major depressive disorder and generalized anxiety.

They gave me some medication, and I hated it. It made me jittery all the time.

At the beginning of my sophomore year I joined an a cappella group because I thought that might help me. I've always loved singing, but that first year even singing in the shower made me sad.

I did have friends. I would talk to my roommate and she would listen very intently. I felt really alone though. I thought "You're sad for me right now, but you're about to go home to your house and Christmas with your family." I just felt so alone in the world with no one to help me. But there were many people that were trying to help me. That also made me feel bad, because I knew they were there trying to help, and I just didn't feel it.

Officer Collier's death was in April of my sophomore year, two weeks before the second anniversary of my mom's death. There was this huge funeral, and I had to go and sing. All I could think about was death and all the tragedy that had gone on at the Boston Marathon. I was sad because people were dying. Then I would feel guilty and selfish. There are people dying everywhere, I thought. Why am I not sad for them? Why am I only sad for my mom?

At this point my classes were going horribly. I was required to withdraw, and I went back to Puerto Rico. This is where things started changing. I ended up staying away for a year. I had to choose a place to live, so I chose to live with my great-aunt. I started to be treated regularly. I realized if I wanted to go back to MIT, I'd have to do something about it. I'd have to get better. I started taking my medication every day, and I'd be very consistent about it.

By the end of that year, I just felt so much better. I had learned so many things. I'd realized the amazing family that I had, and I think that made the biggest difference. I worked in a lab for a while. I took music classes, stuff I hadn't done before. For the first couple of months, I was sad about being there without my mom. For example, I had her car. I would drive and be like, "This is my mom's car. Why am I driving this?" After I started getting treated, it was like, "Oh, nice, I have a car."

Coming back to MIT was hard. I was assigned an amazing new advisor, and he helped me in so many ways. Also I had a lot of help from the deans at Student Support Services. My first semester back, I retook 8.02, Physics II. I remember it being hard again, and I was sad and stopped going to class. Then I realized: no, this is something that has happened before, but I

know what I can do about it. I let my therapist know and contacted my professor, and he was amazing. He would meet with me every week and help me out. It was such a big shift from my first two years here. I think the biggest thing I learned from being away was that you can always ask for help and there will always be someone to help you here. That's something I just didn't know before.

I'm off medication now, but I still go to my therapist every month. I feel like a much better person than the person I was in high school. I feel as though I've learned so much, that I have developed so much patience. I've also learned how to be a lot more proactive, making sure everything is on time.

I'm proud of where I am. I am proud of what I've done, but the thing I'm most proud of is that I was able to get help. In that sense I don't feel that where I am today is my accomplishment alone. I feel it's an accomplishment of everyone around me.

When I talk to other people who are depressed, the thing that I most want them to know is that it will end. It's something that takes effort. I put in so much effort to get better. Even if you're 100 percent sure that there is no way for you to get better, there will be a way, and it doesn't matter how long it takes you to find it.

Caterina Colón, Class of 2016, is a Research Associate at the Koch Institute for Integrative Cancer Research.

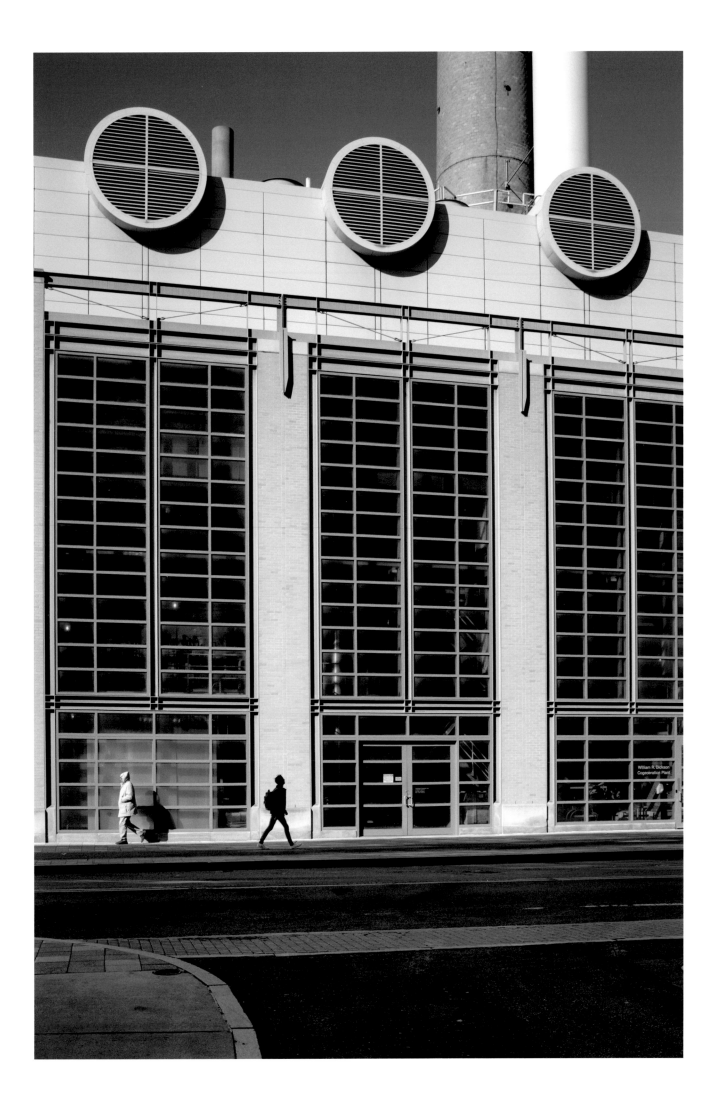

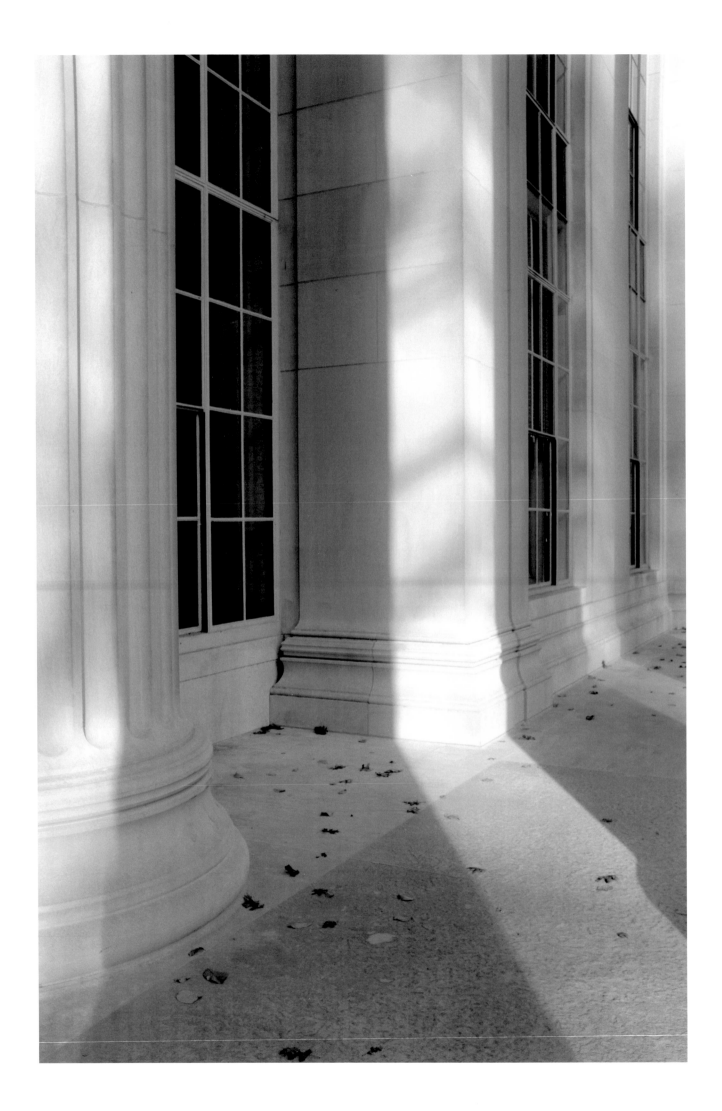

Acknowledgments

The main thing is that one must struggle
with all one's strength to be joyous always.
It is the nature of man to be drawn
into melancholy and sadness because
of the things that happen to him.
—Nachman of Bratslav (1772–1810)

Since this project began two years ago, I have been astounded by the generosity of my subjects. Surely at any moment they would withdraw their consent, decide that telling their stories to me was enough, that sending them out in the world in a newspaper, then a blog—and now, finally, a book— would be going too far. And yet they greeted every opportunity to retreat only with more enthusiasm, encouraging me to forge ahead.

A joyous life is not bestowed but earned, often by struggle—for my subjects, an epic struggle that calls for all one's strength. I feel humbled and honored that they chose to share their struggles with me. The poet Robert Lowell asked: "Yet why not say what happened?" There were, of course, many good reasons, but in their courage and altruism, they decided to say what happened nonetheless, and we, the recipients of their openness, are deeply grateful.

My own life has been enriched immeasurably by my encounters with these remarkable individuals—my "community of portrait people" (to use Haley's lovely term). They have taught me that joy can be found even in dark times, how to find a path to it, and how to overcome obstacles along the way. Their portraits are for me not only a record of their wisdom and resolve but also treasured mementos of the times we spent together.

I am so grateful to David Karp for his wonderful foreword. Through the contributions of his distinguished career and through his own resilience, he is a model of insight and empathy. I could not have hoped for a better appreciation of my project, or a more articulate distillation of its underlying themes—in particular that depression is not just a medical phenomenon but a social, cultural, and political one too.

Many friends and colleagues were instrumental in making this project happen: Alice Zielinski, who worked with me to promote the project, connected me with students, and pitched the idea of weekly installments to *The Tech*, MIT's newspaper; Kathleen Xu, the editor who oversaw their publication; Kirsten Olson, who introduced me to Sara Lawrence-Lightfoot's essay on Dawoud Bey (in her book *Respect*) and encouraged me to develop the relational aspects of my photography; Maria Rebelo, my administrative assistant, who was always on hand to help with arrangements; Maryanne Kirkbride, who helped raise funds and oversee the distribution of the book to students; and Jon Bentley, Peter Fisher, Tish Miller, Linda Rabieh, Haleh Rokni, Evan Waldheter, Katha Washburn, Tamar Weseley, and Jay Wilcoxson, who gave help and advice on various aspects of the project.

My photography teachers—Arno Minkkinen, Keith Carter, Cig Harvey, Joyce Tenneson, Connie Imboden and Brenton Hamilton—instilled in me the quintessential paradox of photography: that photographs are both seen and made, so the photographer must, at the same time, relinquish control and yet account for every detail. Joyce and Connie, in particular, as well as Sean Kernan, looked over an early draft of the book; and Brenton's incisive critique gave me the courage to call up some of my subjects and ask to photograph them a second time.

For many years now, the highlight of my summer has been the time I've spent at the Maine Media Workshops. Of the many photographer friends I first met in Maine, two deserve special mention: Kristin Rehder, for her inspiring work with refugees, and Jeannie Hutchins, who, in addition to being a fine photographer, posed at 6:00 a.m. in not very warm water for the photo that won me the Zeiss lens that these portraits were taken with.

Tim Whelan, whose little bookstore has the best collection of photobooks anywhere, shared his extensive knowledge of books and printing with me and helped me navigate the world of publishers and printers.

I have been overwhelmed by the support this book has received from my colleagues and from my university community at large. Grants from the MIT Council for the Arts, the MindHandHeart Innovation Fund, the Margaret MacVicar Faculty Fellows Program, and the support of Henry Lichstein made the book's

publication possible. An anonymous matching donor organized an alumni campaign that will give a copy of the book to each of this year's incoming students.

Katie Helke, my editor, has overseen the book's journey from start to finish. The result is much the better for her wise judgment, impeccable taste, and stylistic sensibilities. She has been a true collaborator and a great advocate, and her confidence in this unconventional project never wavered. I am grateful also to Gita Manaktala, editorial director of the Press, for her early enthusiasm for the book, and to Yasuyo Iguchi, who designed the book's beautiful exterior and shared her expertise on the choice of materials.

To my family, I cannot say thank-you enough. My parents encouraged my interest in photography from its earliest days, buying me my first camera and tolerating toner spills in the bathtub. My children have contributed in their own ways. Rachel, as our resident designer, has always been on hand to advise on matters graphic and typographic. My own artist books that I have made over the years now look distinctly amateurish next to Rachel's sewn bindings, clamshell boxes and foil-stamped cases. Rebecca has been my muse in two ways: as a cultural critic, talented writer, and passionate social activist who has sensitized me to the needs and concerns of others; and as my favorite (and most patient) photographic model. Akiva epitomizes R. Nachman's wisdom, and his consistently joyous temperament is an inspiration.

My soulmate, Claudia, has been my companion in all my adult journeys, photographic and otherwise. Her enthusiasm for this project, her promotion of it when I was too shy, and her optimism whenever difficulties arose, have been indispensable. In her new rabbinic career, she has discovered how important it is to talk with people about hard things. I am awed by her ability to do this with true kindness and authenticity, and thankful that a little of it has rubbed off on me.

Finally, I must acknowledge the people, near and far, who motivated this project—the ones who have yet to tell their story. May they find strength and resilience in their own struggles on the path to joy.

Daniel Jackson
September 2017

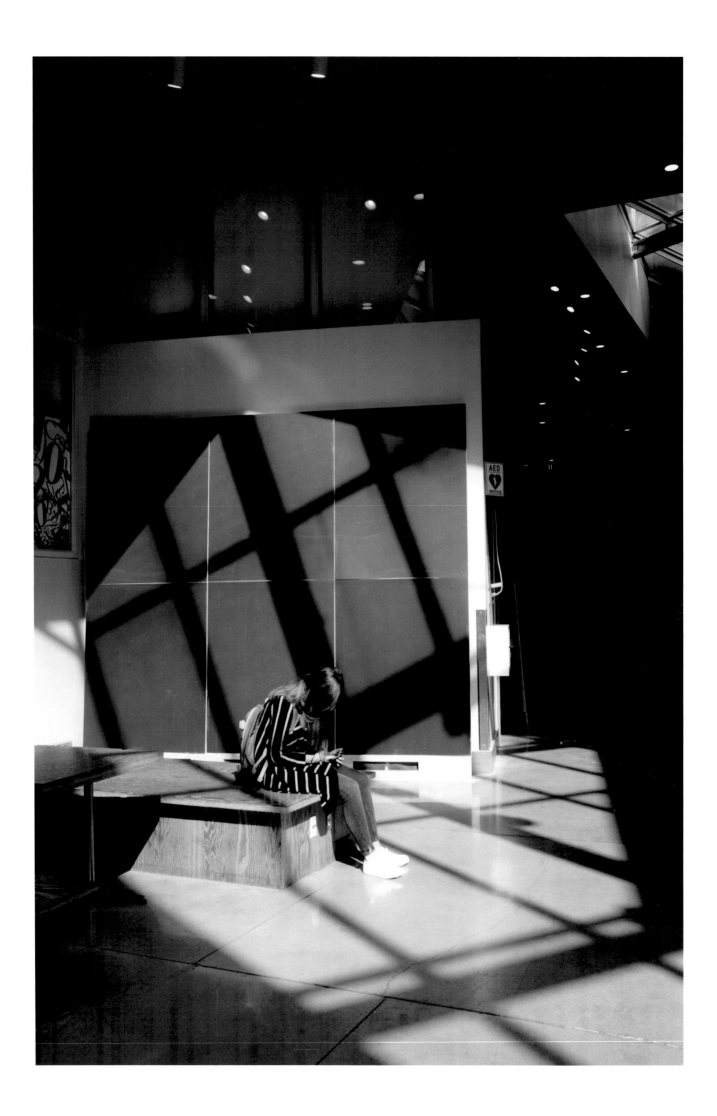

Resources

For immediate help

If you are in crisis and in need of immediate support or intervention, call the National Suicide Prevention Lifeline at (800) 273–8255, or visit their website at https://suicidepreventionlifeline.org. Trained crisis workers are available 24 hours per day, 7 days per week. If the situation is potentially life-threatening, call 911 or go to a hospital emergency room immediately.

Finding treatment

For general information about mental health and to find mental health services in your area, call the Substance Abuse and Mental Health Services Administration (SAMHSA) Treatment Referral Helpline at 1–800–662-HELP (4357).

Other useful resources

· Anxiety and Depression Association of America
 www.adaa.org
· Depression and Bipolar Support Alliance
 www.dbsalliance.org
· Mental Health America
 www.mentalhealthamerica.net
· National Alliance on Mental Illness
 www.nami.org
· National Institute of Mental Health
 www.nimh.nih.gov

MindHandHeart

Visit https://mindhandheart.mit.edu to learn more about MindHandHeart, an initiative to enhance mental health and well-being at MIT, by helping members of the MIT community feel more comfortable asking for help when it's needed, and building a stronger, healthier, and more welcoming community.

Please note that these resources are provided for informational purposes only. This list is not comprehensive and does not constitute an endorsement by the author, the MIT Press, or the Massachusetts Institute of Technology.

List of Plates

Stata Center, Gates Tower iv

Saarinen Chapel viii

Killian Court patio xii

Dreyfus Building xvi

View down Vassar Street 4–5

Window, Stata Center 21

Stata Center, from author's office 27

Nuclear reactor 38–39

Front steps, Rogers Building 49

Elevator, Lobby 7 69

Power plant and annex 75

Lobby, Building 34 80–81

Chairs, R & D Commons, Stata Center 99

Whitaker Building 109

Cogeneration facility 123

Killian Court patio 124

Student Street, Stata Center 128

Entrance, Lobby 7 133